The CARTOONIST'S BIBLE

Terry Simpson

foulsham
LONDON · NEW YORK · TORONTO · SYDNEY

foulsham

The Publishing House
Bennetts Close, Cippenham, Berkshire, SL1 5AP, England

ISBN 0–572–02390–1

Printed in Great Britain

CONTENTS

INTRODUCTION

Congratulations! By opening this book you are stepping into the exciting and rewarding world of cartooning.

The Cartoonist's Bible is a fun-packed illustrative guide dedicated to all areas of cartooning, from character creation to animation.

The secret art of drawing cartoon heads and faces, bodies, hats, cars and helicopters, objects and props, explosions, fight clouds and scenery are never more than a few pages away, all with broken-down, easy-to-understand, step-by-step techniques.

Want to draw cartoons for a living? Look no further! *The Cartoonist's Bible* dives deep into the professional side of cartooning, unravelling the mysteries of pocket jokes, comic strips, greeting cards, portfolios and freelancing, including how and where to sell your work . . . you can't go wrong!

The Cartoonist's Bible has many years of cartooning skill, tricks of the trade and useful general knowledge crammed into its pages, creating an invaluable tool for all budding cartoonists plus those already in the trade.

So whether you wish to push your new-found talent towards a full-time career, profitable sideline or just want to impress your family and friends and Auntie Flo, you'll always have a talent to cherish but most importantly of all . . . HAVE FUN!

PART ONE

FIRST THINGS FIRST

GETTING STARTED

OK, you've got the urge, some spare time and the motivation, what more could possibly be needed? Well, a sharp pencil wouldn't go amiss. Almost everything else needed to break into the world of cartooning, either for fun or a career, is probably lying around your home or office, collecting dust in a junk drawer somewhere right now. Items you don't possess can be purchased quite cheaply from any stationery shop.

PENCILS

When it comes to pens and pencils, it's normally a case of each to their own. Experiment to discover what suits you best. Personally, I use a 0.3mm nib for inking and an HB pencil for sketching.

NIBS

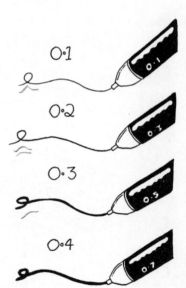

0·1

0·2

0·3

0·4

ERASERS

Erasers are erasers, right . . . ? Wrong. The prize for the most useless invention goes to the rubber tipped pencil. Do not use these erasers as they can and will kill your drawings. Instead use a big, bold and boring one.

I AM BORING!

ALWAYS USE 80gms PHOTOCOPIER PAPER

A PLACE TO DRAW

I thought words such as tidiness, cleanliness and organisation would gracefully vanish once I left home. Unfortunately, they came back with a vengeance for my cartoon years and quite rightly so. It is important to have your own space to draw and keep your work safe. Ever heard someone say 'Well, it was on the floor so I threw it away!'?

Cartooning for FUN!

Cartooning has always been with us since the beginning of time. Cavemen doodled in caves, the Egyptians doodled in pyramids and the Romans doodled in, well, Rome. Why? Because it's fun! It's a great source of entertainment for everyone.

Cartooning contains an extremely large fun factor and this is reflected in the work produced. So, for example, a comic strip drawn by someone with a lively and humorous attitude towards life will amuse much more than one drawn by Mr Morbid. So remember, whatever reason you are entering cartooning, the main reason should be for FUN. Now grab that pencil and get to it!

EXTRAS

Paper clips

Ruler

Drawing pins

Clipboard

Pencil mascot (very important)

Scissors

Ring binder

Ideas notepad

Endless supply of tea

LET'S DRAW HEADS

If you want to be a good cartoonist, then you need to be capable of drawing a good head (unless you only wish to draw guillotine victims). The head and face are the most important parts of a cartoon character because they let your audience know what your character is, for example, a man, woman, child, intergalactic space warrior, whatever; it is the main source of identity! All good cartoon heads are built from a solid structure and once this is understood, drawing faces will become second nature to you. Without a solid structure the face would seem flat and drawing it at various angles would be an absolute nightmare.

Popular Head Shapes

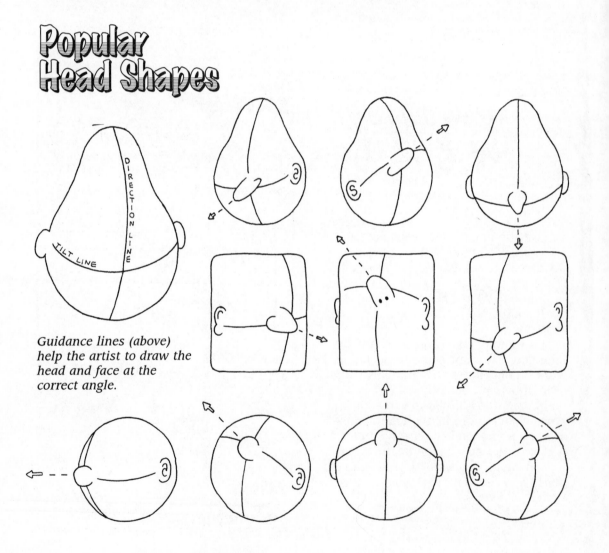

Guidance lines (above) help the artist to draw the head and face at the correct angle.

8

Adding More Detail

Building a cartoon head and face is only as difficult as you make it. The rules are simple . . . Choose a starting structure and then mould on the eyes, nose, mouth, ears and some hair and a character is born – simple! Below is a typical example of character creation.

Ears

Nose

Eyes

Mouth

Hair

Shape up

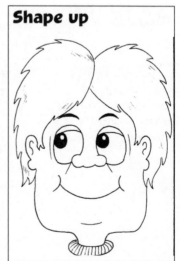

Facial Elements

1 nose + 2 eyes + 1 mouth + 2 ears = 1 face. (As if you didn't know already.) Before you plough into drawing complete heads, practise drawing the elements that go into creating it. Being able to draw lots of different facial features will give you the ability to draw much more varied cartoon faces.

EYES

The eyes are the most important part of the whole character as they are the first part that we make contact with. Eyes are also the main creators of expression, so they have to look correct.

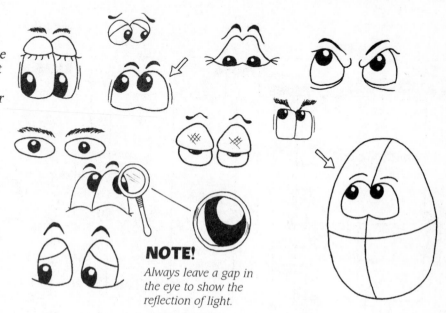

NOTE!

Always leave a gap in the eye to show the reflection of light.

NOSE

Almost any shape or squiggle can be used for a nose. (Nostrils are optional.)

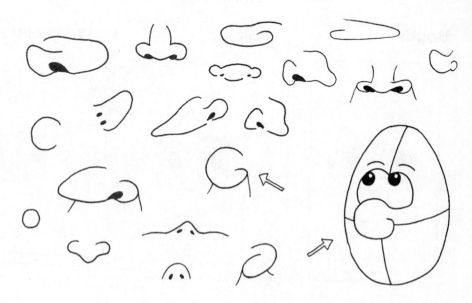

10

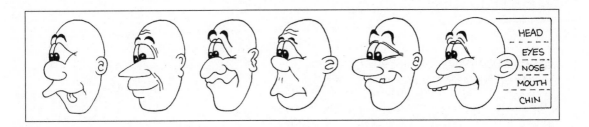

MOUTHS

A simple straight or bendy line can be drawn for a closed mouth. For an open mouth you will need to remember the three Ts . . . tongue, tonsils and teeth.

& EARS

Ears are ears, what more can I say?

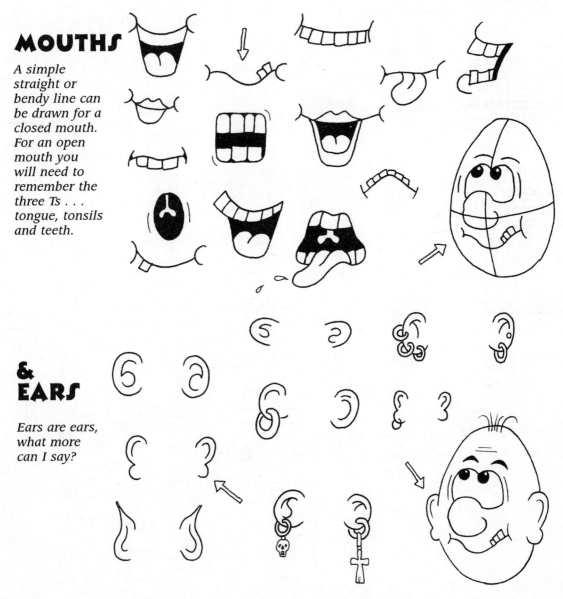

Learn to Turn

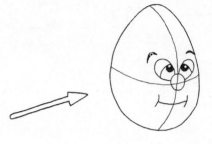

As I've already explained, as long as you build your cartoon face on to a solid structure then turning it around won't be too difficult. Try this experiment: get an egg and draw a face on to it and twist it around, study how the face disappears when rotated and learn from this.

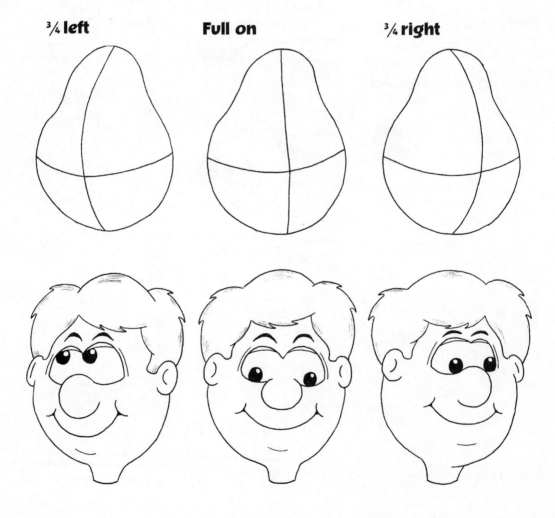

¾ **left** **Full on** ¾ **right**

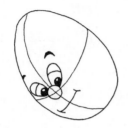

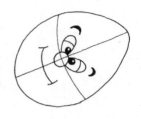

Right profile

Back tilt

Forward tilt

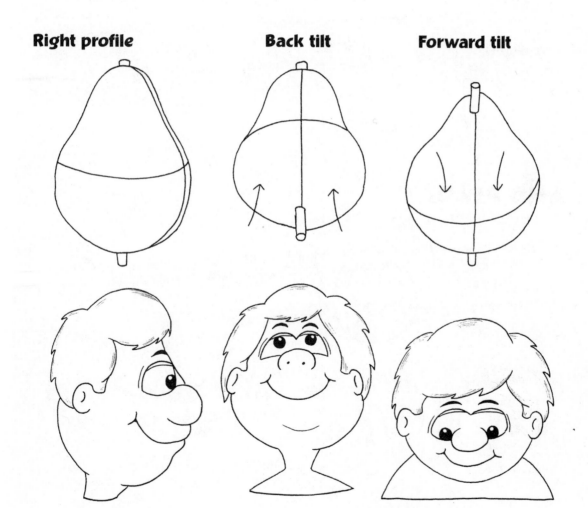

13

Let's Twist Again

CYLINDERS

¾ left　　**¾ right**　　**Right profile**　　**Upward tilt**

AND PEARS

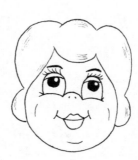

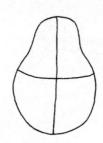
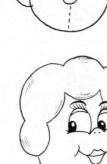

14

BULLETS

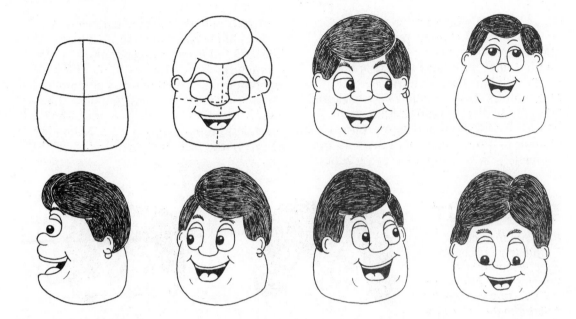

AND OVALS

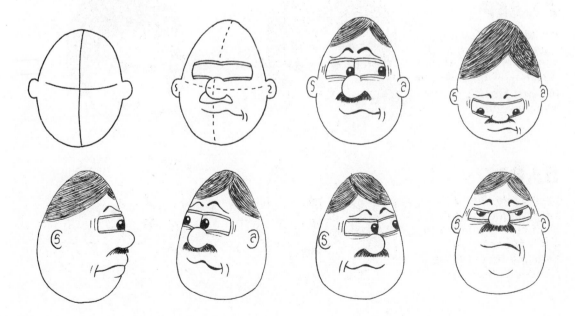

HAIR-STYLES

O K, grab those scissors, find that comb, nick your auntie's pre-war curlers and let's get down to some serious hairdressing! Try to give your characters the type of hair style suited to their personalities. For example, short back and sides for an alert person or long scruffy hair for the layabout and so on. Draw in the hair by either blacking in the hair area completely or by using a sweeping action with your pen, or, as some cartoonist's prefer, simply leave the hair area blank (this is good for showing grey hair in old characters). Experiment with the three techniques as shown below. I personally try to give all of my characters black hair most of the time as this gives tone and contrast to the drawing and separates the hair from the face, making it easier on the eye.

BLACKOUT

Blacking in the hair completely is the most effective method of drawing hair but try to leave a couple of dashes where the hair changes direction.

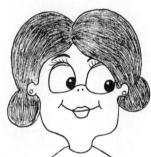

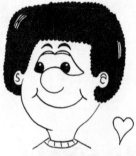

SWEEP

For this style, simply sweep your pen quickly, softly and evenly in the direction of the hair. For the best results, use a 1mm pen nib.

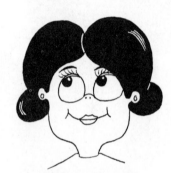

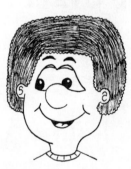

BARE

Leaving the hair area bare can look just as good but try to draw in a few strokes of hair here and there to give it some texture.

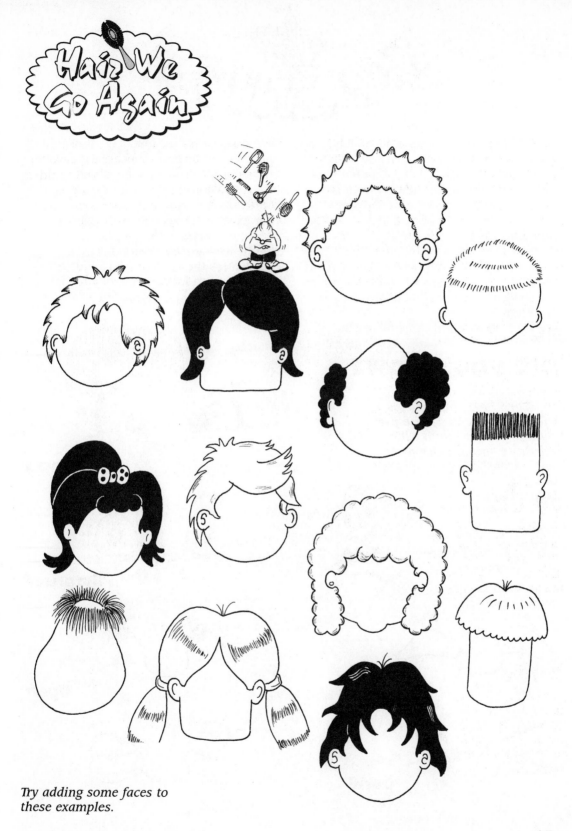

Hair We Go Again

Try adding some faces to these examples.

EXPRESSIONS

Where would us mere mortals be without any expression? Can you imagine a place where nobody laughs, nobody cries, frowns or smiles? (Apart from the local post office queue.) An expression could best be described as a facial reaction to a situation. For example, look in the mirror and whack your thumb with a hammer . . . watch your face as you scream (just kidding!). But do look in the mirror and pull some faces. What happens to your eyebrows when you frown? Maybe they go up! What about when you smile or laugh?

How does your face react? What new lines appear, what lines disappear? Experiment until your face feels like it's about to drop off. Expressions within your cartoon characters are vital, they give your characters life; they can even give your characters a character! A cartoonist simply takes an expression and exaggerates the lines and facial features so that the reader can instantly recognise what emotions and moods the character is feeling.

DID YOU KNOW?

Expressions are created almost entirely from the eyes and mouth. The way these two features are drawn can tell us whether someone is happy or sad, curious or crafty, infuriated or indecisive and so on. In fact, no matter how a face is drawn it will inevitably depict some sort of expression.

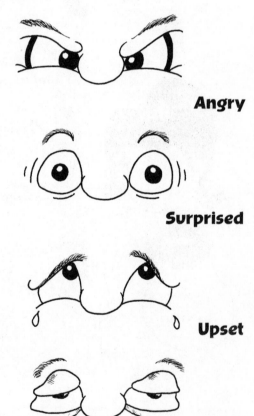

Angry

Surprised

Upset

Tired

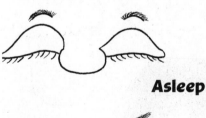

Asleep

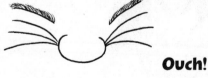

Ouch!

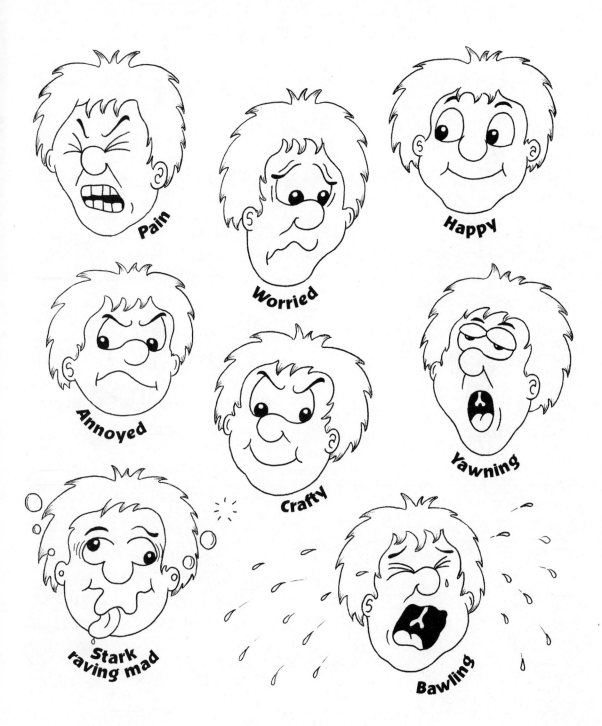

Pain

Worried

Happy

Annoyed

Crafty

Yawning

Stark
raving mad

Bawling

And a Few More

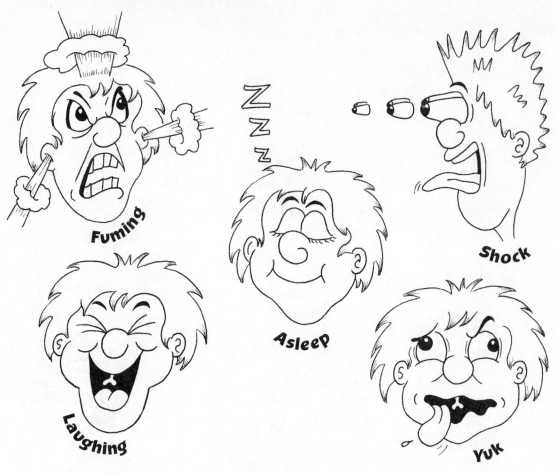

Fuming

Asleep

Shock

Laughing

Yuk

Get a mirror, get drawing but... don't get caught!

TEE HEE HA HA

Extend Your Expressions with Visual Props!

Visual props such as halos and lightbulbs are always great for further expressing your characters' emotions. Try to incorporate them into your drawings as much as possible to make your cartoon scenes more fun and amusing to look at.

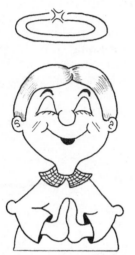

A halo can be drawn for when one has been good.

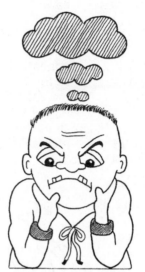

A dark cloud shows deep, depressive thoughts.

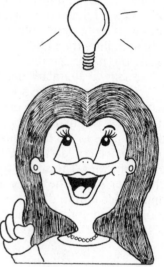

Aha! A bright bulb means a bright idea.

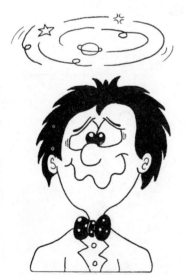

Oooh. Spinning stars for a sore head.

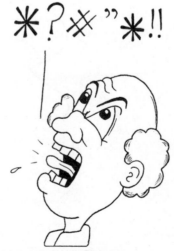

Typography is how a cartoon character swears.

The question mark tells us this guy is clueless.

VARIETY in your FACES

If we were to draw a cartoon character (regardless of its age and sex) with a small nose, big bubbly cheeks, wide eyes and a high forehead, it would look cute and would retain its cute appearance whilst pulling the ugliest of expressions. Quite often, we can tell what type of personality a character has just by its physical features. Take a look at the dim-wit character below; we don't know his name, age or anything about him but just one glimpse of his face tells us that his intelligence couldn't exceed that of a stale glass of water. The secret to creating a character's face the way you want it to appear lies within observation, so take a look around you! Do serious people have distinctive straight head lines, do happy

people always have big noses? You've heard the term 'never judge a book by its cover'. This is very true, but not always in cartoons. You may want to create a character that is very clever but looks as thick as a plank, which would be OK in animation or a long-running comic strip as the audience has time to get to know the character; but for single jokes or one-off appearances, it is best to portray the character's personality through its physical features.

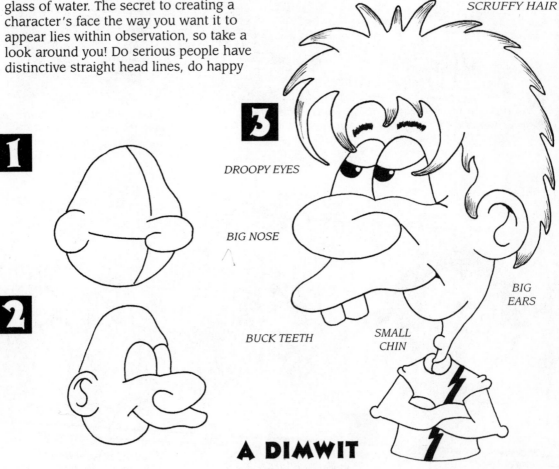

SCRUFFY HAIR

DROOPY EYES

BIG NOSE

BIG EARS

BUCK TEETH

SMALL CHIN

A DIMWIT

People Perception

If you stared at a complete stranger in the street, nine times out of ten you should be able to tell what kind of person they are (this is after you receive a torrent of abuse for staring at them). Visual perception will greatly help you in creating stereotypical characters. Try to train yourself mentally to know what type of features belong to particular characters.

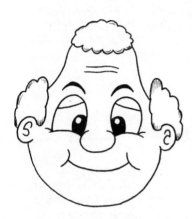

Let's start the cycle with an average elderly character.

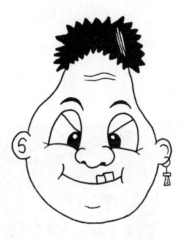

Change the hair and nose to turn him into Terry the teenage thug.

Tidy the hair, lose the earring and square the jaw for a respectable young man.

Droop the eyes, drop some teeth and look . . . the Village Idiot.

Lose the teeth, grow some hair and we have laid-back Larry.

Change the nose, add some lips and lashes for Sarah the secretary.

STEREOTYPES

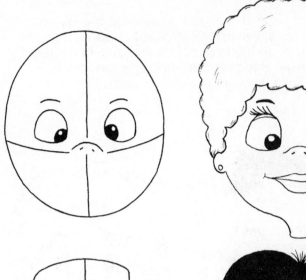

Who is this? Could she be an axe murderess, a high-flying executive or the crazy cat woman down the road? Personally, I'd say she was simply plain Jane from the launderette.

We hired this chap from Hooligans-are-us. What gives him that distinctive yobbo appearance? Could it be his bulbous nose, or is it those dark rings around the eyes or that dodgy ear-ring?

What a boring-looking character. This guy would probably send you to sleep on your feet. Try creating some of your own dreary characters.

Elastic

ey, c'mon people, this is cartoon land, not real life! Get the most our of your characters. Create new and amazing expressions and situations by literally stretching your cartoon faces to the max! A cartoon face (and body) can be kicked squashed, squeezed, splattered, twisted, pulverised and even exploded into oblivion without causing any permanent damage to the poor individual concerned. Always remember that in cartoon land, no rules of nature exist. A cartoon character can be thrown off a high cliff, run over by a steam train or have a stick of dynamite shoved down its neck and still make a speedy recovery . . .

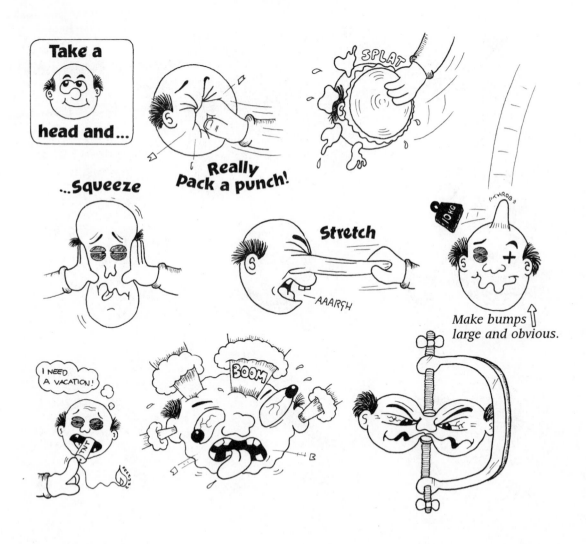

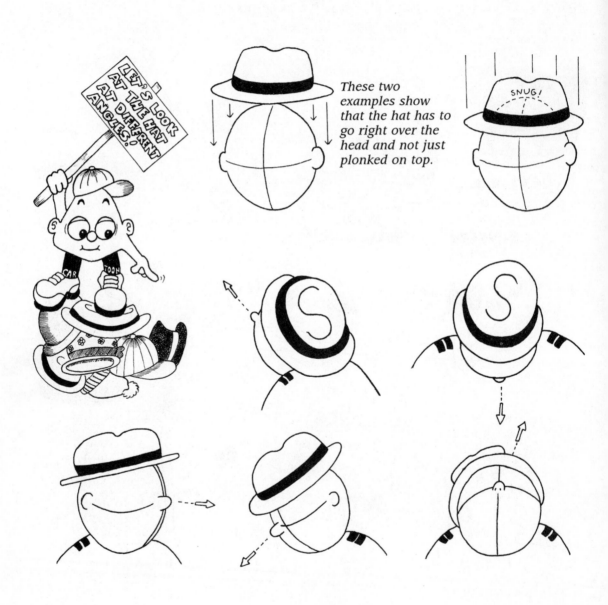

Hats

Hats (and other headwear) can go a long way in establishing your character's identity, although they can prove to be quite tricky to draw properly as they have to sit over the head at the correct angle. A lot of cartoon characters wear hats; for example, policemen, nurses, construction workers, traffic wardens, firemen and chefs, etc., are rarely seen without their hats.

These two examples show that the hat has to go right over the head and not just plonked on top.

SNUG!

LET'S LOOK AT THE HAT AT DIFFRENT ANGLES.

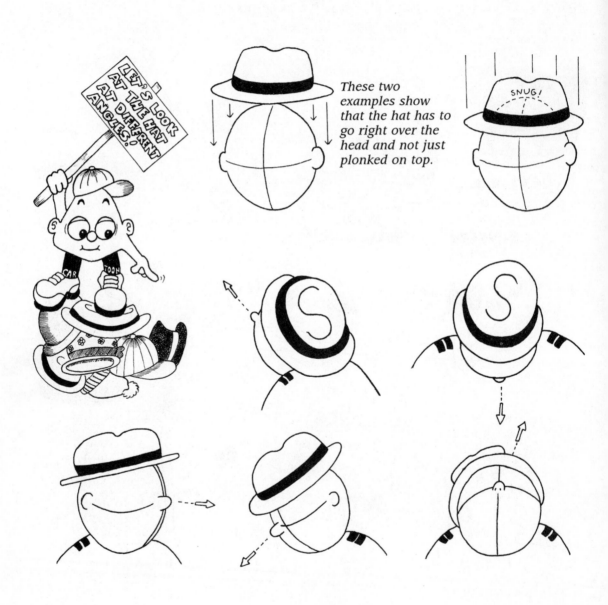

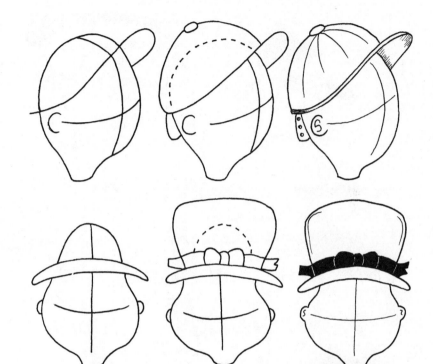

NOW YOU TRY

Draw the rim of the hat over the head at the correct angle. This is the difficult bit and once mastered will make the rest of the hat easy.

Add the rest of the hat. Don't give it a head-crushing look, keep it loose-fitting.

And finally, draw in any patterns and extras it might have. Simple.

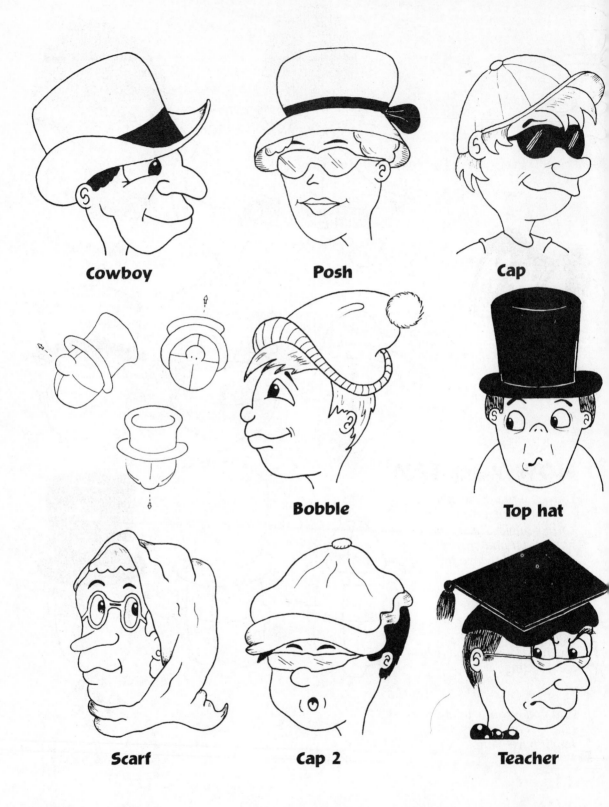

Cowboy

Posh

Cap

Bobble

Top hat

Scarf

Cap 2

Teacher

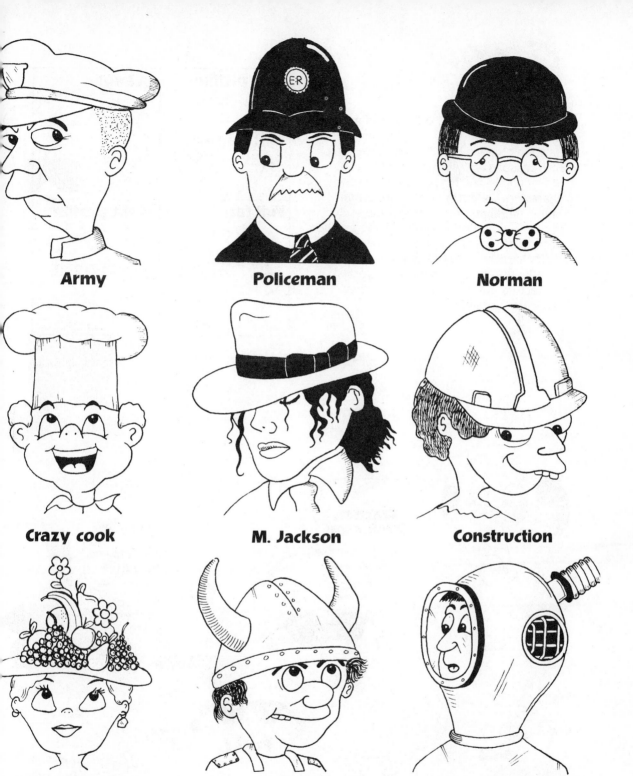

Army

Policeman

Norman

Crazy cook

M. Jackson

Construction

Erm, yes ... ? ! *

Viking

Deep sea diver

Glasses

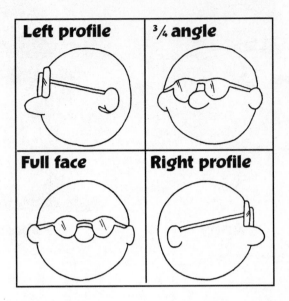

Us humans have only one main reason for wearing glasses – bad vision. Cartoon characters, however, have their own reasons – to show personality and individuality. The type of goggle-eyed characters we normally see are either highly intelligent (a boffin), completely brainless (a buffoon), or an ageing teacher or professor (a bore), but why you give your characters glasses is your choice.

Glasses can be drawn on to your characters in the same way that they are worn by humans.

Left profile	¾ angle
Full face	**Right profile**

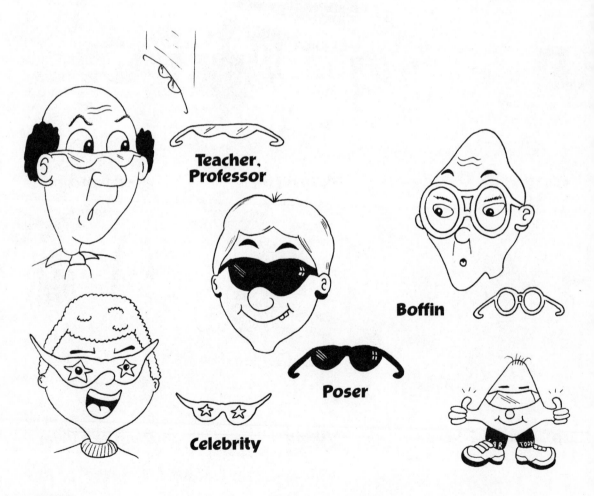

Teacher, Professor

Boffin

Poser

Celebrity

30

Beards

Whenever I create a new cartoon character, I always draw on some facial hair. If it looks good, it stays, if it doesn't, it goes. Beards and moustaches can add a lot of depth instantly to your character's personality and although not many characters have beards, those that do are instantly recognisable and stand out from the rest of the crowd.

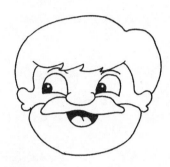

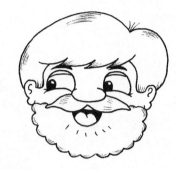

1 *Start by drawing your character's head.*

2 *Map out where you want the beard to go.*

3 *Finally shape up the beard . . . job done.*

Razor phobic

OK... Your Turn!

So far, all I have shown you are a few average cartoon character faces, but using a combination of different shaped noses, eyes, mouths, hair-dos and head shapes makes it possible to create literally millions and zillions of cartoon faces! The more you practise and experiment, the better you'll become. Before long you'll be drawing grandads and grannies, secretaries and mean bosses, crazy kids and grumpy park keepers and on and on, so what are you waiting for? Sit down, grab your pencil and get some of these possibilities on to paper!

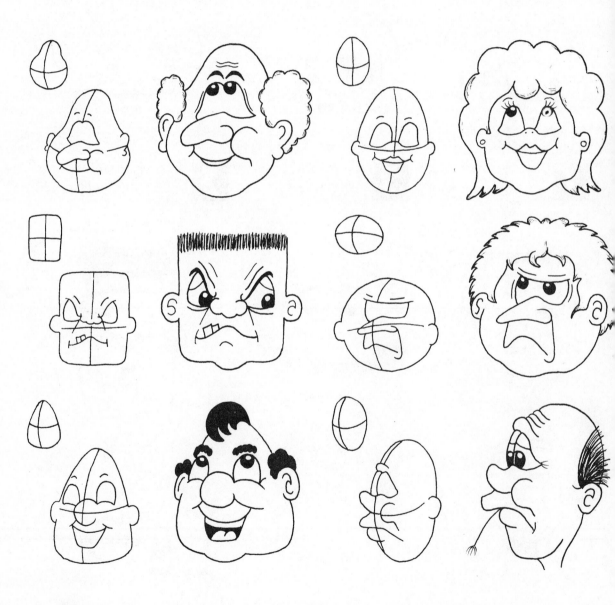

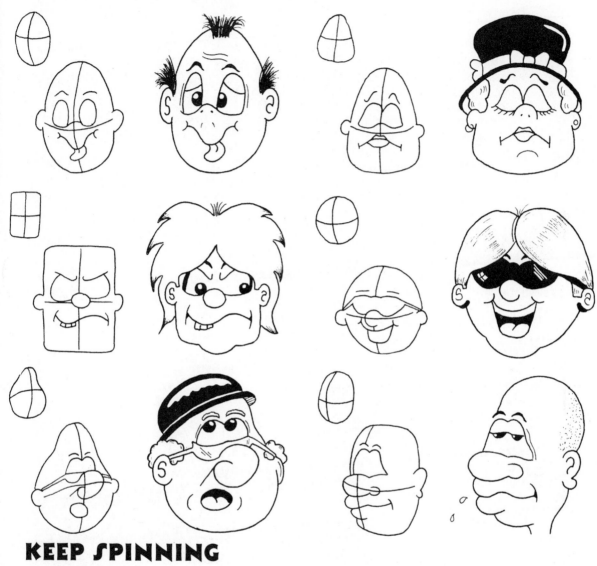

KEEP SPINNING

33

HANDS

Believe it or not (I'd prefer you to believe it), hands are just as important as the head and face. Not only do hands do the obvious, such as hold your cup of tea and point lost tourists in the right direction, they can also tell us what mood a cartoon character is in. It's true! For every facial expression we can rustle up, there is also a hand position to match. These are known as expressive hands (I'll explain that later) but what we need to concentrate on first is the construction of the hand and how to hold and grab various objects.

Take a look at the illustrations on the right: there are many lines and wrinkles but fortunately, it is not necessary to draw any of these, or the fingernails, in (pity the poor character that wants his palm read).

Many cartoonists choose to draw only three fingers on each hand. This is a technique first put into practice during the early days of animation for speed and simplicity, and is still the most popular method today, so although hands play a major role within the cartoon character, they are in fact, quite simple to draw.

How?

1 *Draw an oval for the palm, three sticks for the fingers and one for the thumb.*

2 *Thicken the sticks to create fingers. Make sure that they overlap correctly.*

3 *Finally, give the palm some definition and exaggerate the base of the thumb.*

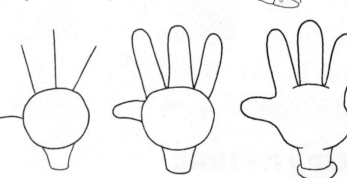

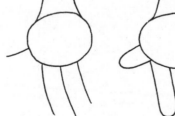

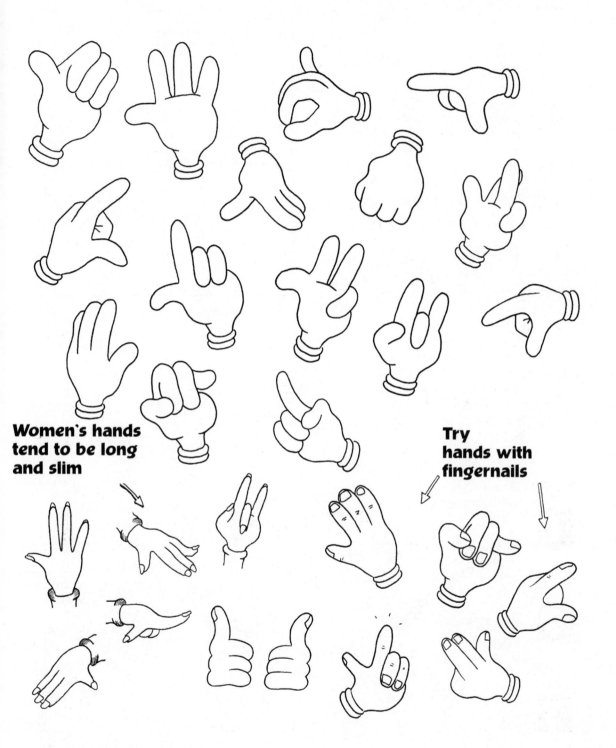

Women's hands tend to be long and slim

Try hands with fingernails

35

Grab It!

The area of hand drawing that presents the most problems is hands holding objects. We need to know what fingers should be covered by the object, what fingers should be visible, what angle the thumb should be at, etc., but fear not, help is at hand (sorry, I'm a sucker for bad jokes). Take a look at how your hand is holding this book (if you're not holding it then pick it up – now!) and study how your hand wraps around it. Does your thumb point upwards or is it horizontal? Can any fingers be seen and if so, which ones? Always try to draw the fingers and thumb around an object correctly to make it more believable.

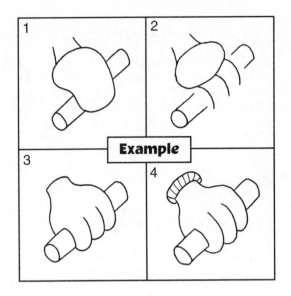

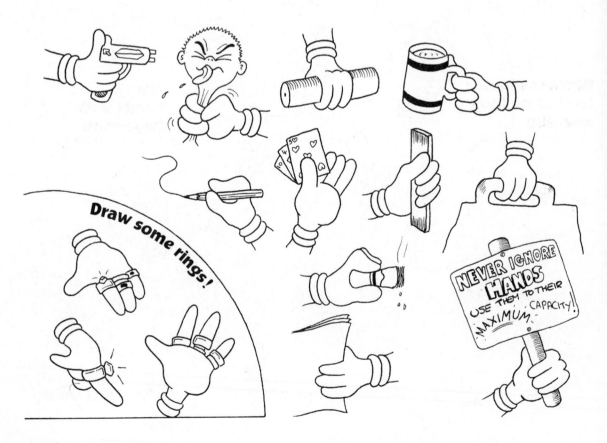

Draw some rings!

Expressive Hands

As explained earlier, hands have their own method of displaying their character's emotions. Have you ever heard the phrase 'body language'? This is a term invented by some nutty scientists after studying human behaviour for a few decades. In basic English, what they are trying to say is that the whole of our bodies (not just the hands) physically react to what we are saying. Imagine an obnoxious work-mate has just received a promotion that was rightfully yours. Along with the rest of your body jumping up and down with fury, your hands would be clenched into fists and waving about like crazy, like the character below.

HANDS WITH ATTITUDE

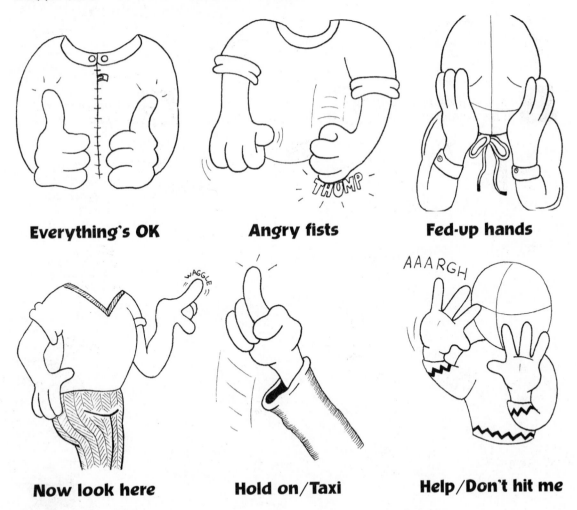

Everything's OK

Angry fists

Fed-up hands

Now look here

Hold on/Taxi

Help/Don't hit me

FEET

And now to a smelly subject. Feet. Cartoon feet are in fact quite rare, or rather all cartoon characters do actually have feet otherwise they would all fall over, but we rarely see them because the cartoonist has usually either put footwear on the feet or only made the top half of the character visible. The construction of feet is similar to that of hands and can be just as important in certain situations.

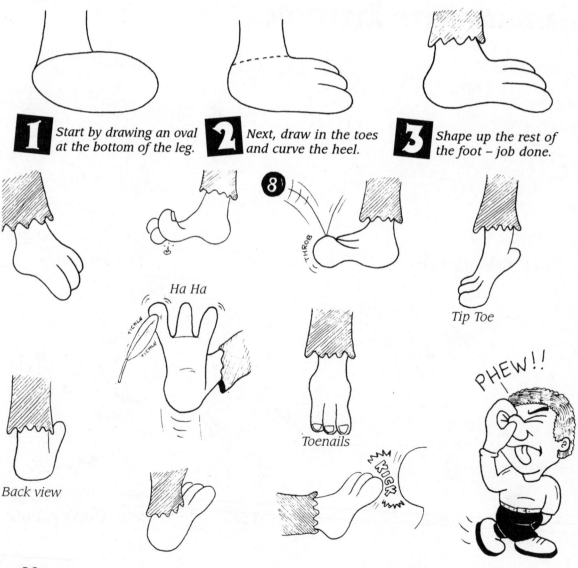

1 *Start by drawing an oval at the bottom of the leg.*

2 *Next, draw in the toes and curve the heel.*

3 *Shape up the rest of the foot – job done.*

Ha Ha

Tip Toe

Back view

Toenails

PHEW!!

Feet Have Feelings Too

For most people, trying to describe the wonders of a foot would be equal to giving a lecture on atomic energy, a few words would lead to brain block and mental shutdown. This is hardly surprising. After all, a foot is not exactly the greatest of subjects, but for all us cartoonists it is a very important piece of anatomy indeed. Feet can work really excellently with legs in showing the weight and density of a cartoon character as demonstrated below.

WEIGHT FOOTPRINTS FEMALE

Show a heavy person by drawing cracked paving stones and sound effects.

Leave a trail of footprints for when walking in sand or dirt.

As with hands, women's feet should be longer and slimmer.

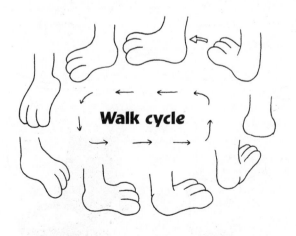

Walk cycle

Socks

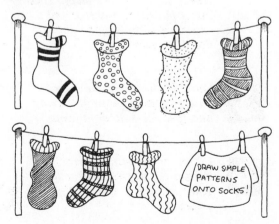

DRAW SIMPLE PATTERNS ONTO SOCKS!

Footwear

Without footwear, your cartoon characters would be extremely unhappy souls suffering from all sorts of nasty cuts and bruises on their feet, so get learning! The type of footwear you should draw greatly depends on the type of clothing your character is wearing, for example shoes with suit, trainers with jeans, slippers with dressing gown and so on.

As with all objects in cartoon land, keep footwear big, bubbly and round in the true cartoon fashion.

Draw an oval at the bottom of the leg at about the size and shape that you want the footwear to be, making sure it is facing in the right direction.

Now the tricky bit. 'Curve' down the oval to form the overall shape of the footwear, add the sole and mark out where you want the laces. This may take some practice and experimenting to get right but don't give up.

Draw in the laces, add any patterns the shoe might have and give the sole definition.

Erase any remaining pencil lines after tracing over it with your pen and it's ready for walking.

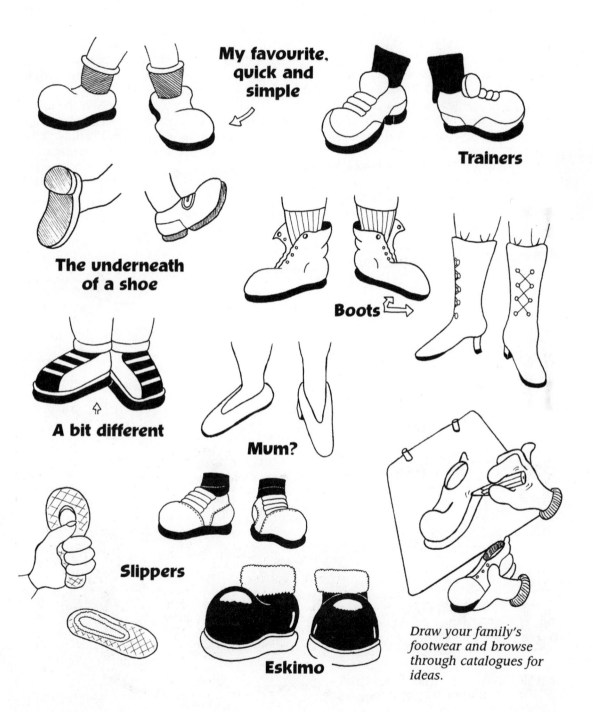

My favourite,
quick and
simple

Trainers

**The underneath
of a shoe**

Boots

A bit different

Mum?

Slippers

Eskimo

*Draw your family's
footwear and browse
through catalogues for
ideas.*

BODYWORK

Can you draw a matchstick man? Of course you can! So you will find little trouble in drawing a full-bodied character because that's all a cartoon character's body is, a very thick matchstick man (no offence, I'm not saying all matchstick men are stupid). When drawing a body, every part of it is put into the limelight. The torso tells us if the character is tall, thin, fat, tiny, a man, woman, or a twenty-first-century slimy mutant with arms and legs emphasizing the character's movements such as walking, running or doing a triple backward somersault, etc.

Take a look at character 3 in the line up below. This chap is approximately 3½ times the height of his own head, which is also the average size and proportion of most cartoon characters. This size of character normally has a dense but cute look to it.

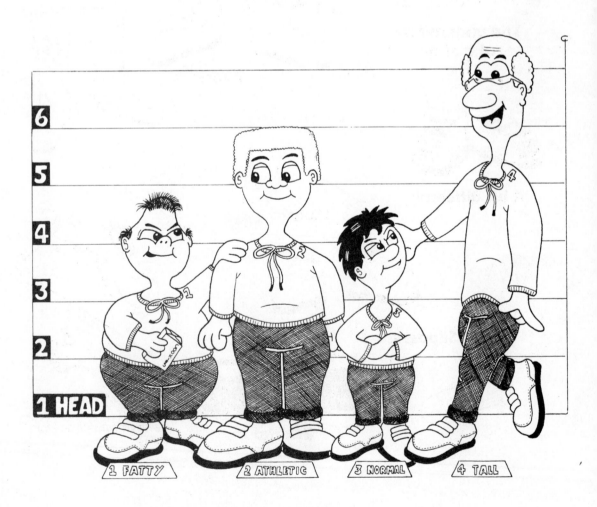

1 FATTY 2 ATHLETIC 3 NORMAL 4 TALL

Proportion

Exaggeration is a word that cartoonists should engrave into their brains for all eternity. In the real world, artists have to abide by the laws of natural proportion. Us scribblers, however, can put proportion on a ship and torpedo it sky high.

SEXY LADY

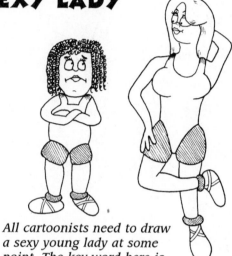

All cartoonists need to draw a sexy young lady at some point. The key word here is curves.

FAT

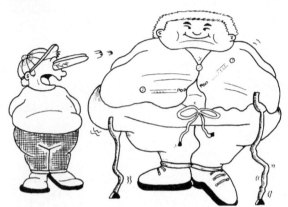

Turn a fat person into a flab-infested obese lump.

OLD

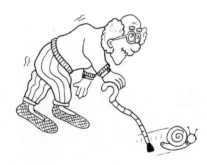

The most distinctive feature of a cartoon oldie is the arched back. Legs and arms should be drawn with a frail appearance.

MUSCLES

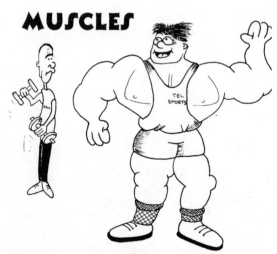

The muscle man should have a massive chest, tiny waistline and no neck.

Let's Draw Bodies ...

STEP ONE

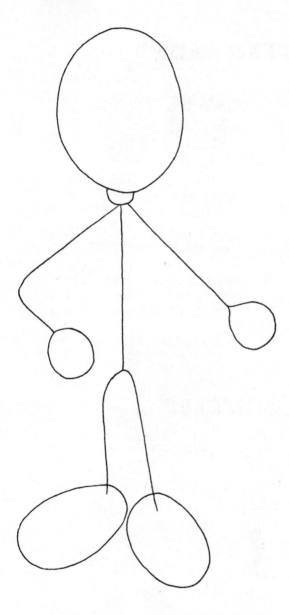

The matchstick man plays an enormous part in drawing a good cartoon body. Think of it as a skeleton, a solid structure around which the body can be drawn (just like the head).

STEP TWO

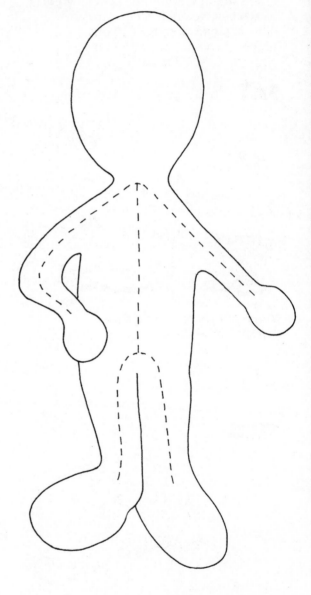

This is the difficult bit where a lot of practice and experimenting should take place. Thicken out the skeleton to create the impression of a body.

...No Problem

STEP THREE

STEP FOUR

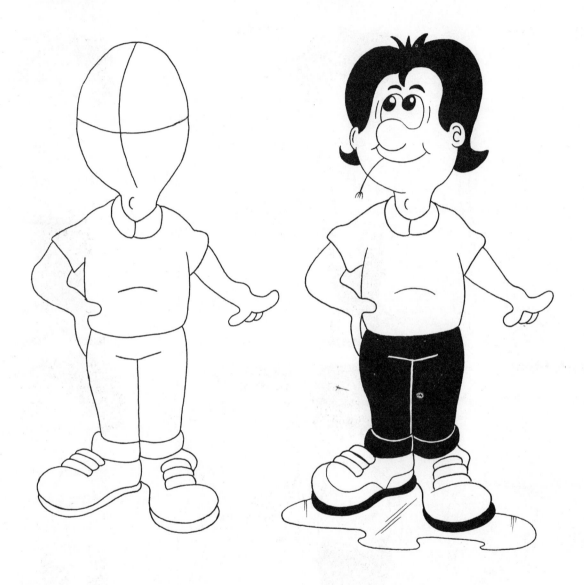

Decide what clothes you want your character to wear, drawing them slightly wider than the body. Also, now is a good time to draw in the hands and feet as shown earlier.

Draw in the face and hair and WOW . . . the character is complete. That wasn't too difficult, was it?

Try Various Angles

Left profile

¾ right

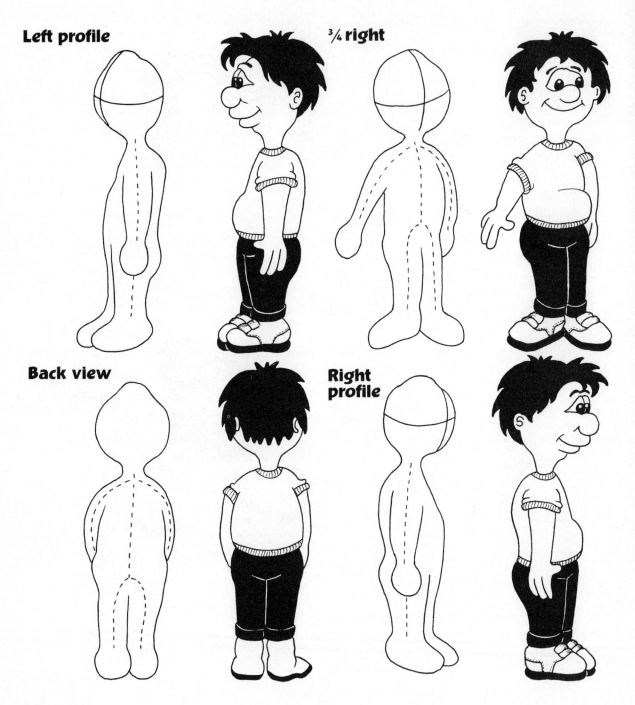

Back view

Right profile

ACTION *Create a Stance*

Action . . . that's the key word to keep in mind whilst drawing. Giving the impression of actual movement to your characters is one of the most important aspects of cartooning. Although we can't make the characters literally move (without animation) we can make them appear to be in motion by drawing them in certain positions and postures related to that particular movement.

If you're not sure how a character should be positioned when running, jumping or diving, etc., then pay your local library a visit. Choose books on subjects such as football, tennis and gymnastics or any sport that involves a lot of movement and use the photos in the books for reference. Remember, if help is there for the taking, then do take it.

THE ACTION LINE

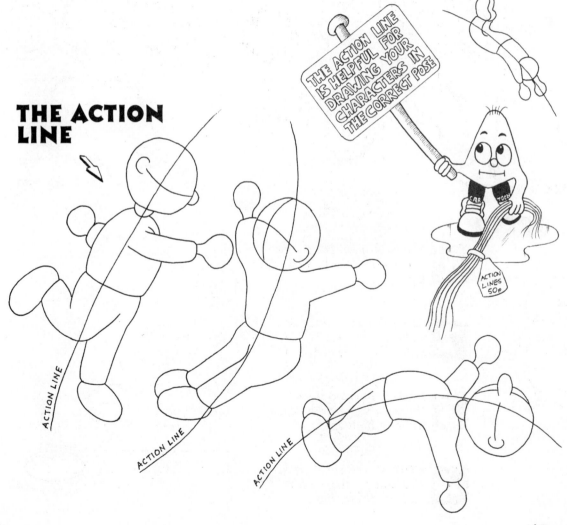

THE ACTION LINE IS HELPFUL FOR DRAWING YOUR CHARACTERS IN THE CORRECT POSE

ACTION LINES 50p

ACTION LINE

ACTION LINE

ACTION LINE

Before we head into deep discussion about movement, there are a number of cartooning special effects you need to learn which are important for a realistic scene. Look at the two illustrations below. The one on the right has been brought to life using a combination of shadows, sweat and speed lines whereas the one on the left, although identical, seems lifeless. No rules exist as to where speed lines should go but always try to draw them behind or with the flow of movement to show what speed and direction the character is moving at.

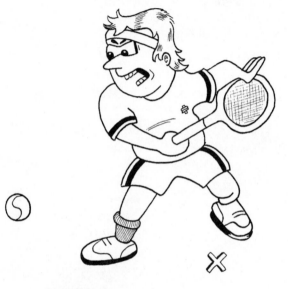

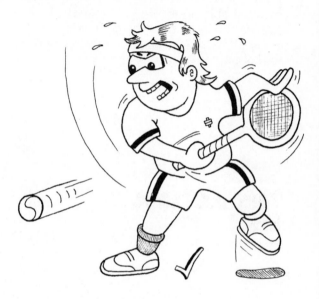

SPEED

1 The ball might be moving but it sure doesn't look like it.

2 Add a few echo lines and we're on the move but only at snail speed.

3 Double the echo lines, throw in some trails and we're at high speed.

4 WOW. Move over Ferrari. This ball's going so fast that it's stretching.

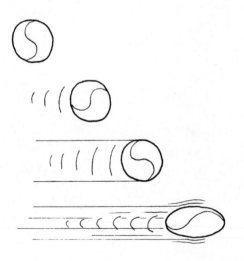

TRY THESE FOR SIZE

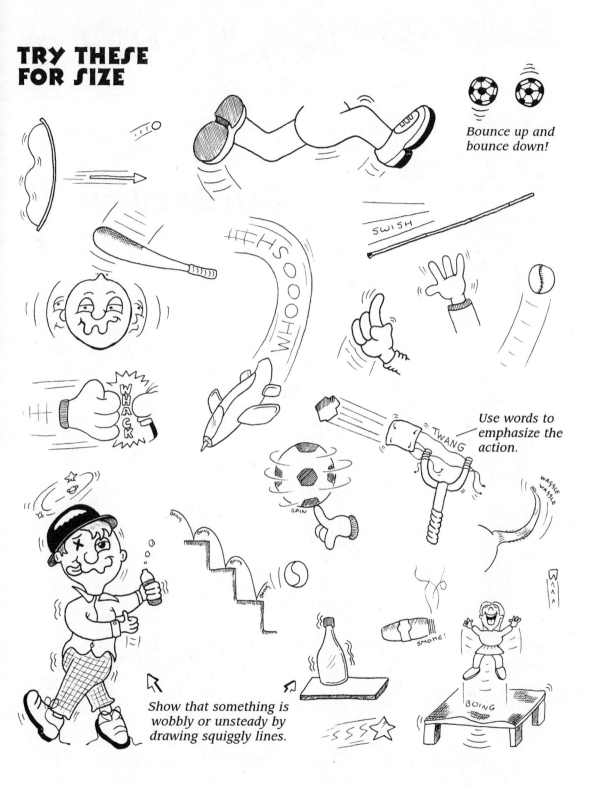

Bounce up and bounce down!

Use words to emphasize the action.

Show that something is wobbly or unsteady by drawing squiggly lines.

MATCHSTICK MADNESS

MEE-OW

Almost anyone can draw a simple matchstick man. They are easy and fun to draw but most importantly they are used as a guide to construct a complete body correctly as you have already been shown.

Don't ignore this section: if you rush straight into drawing complete bodies your results will be disappointing, so instead practise drawing matchstick men in as many different positions as you can think of until it becomes second nature to you.

All of the following examples feature matchstick men of average size and proportion to keep it simple.

Bare Essentials

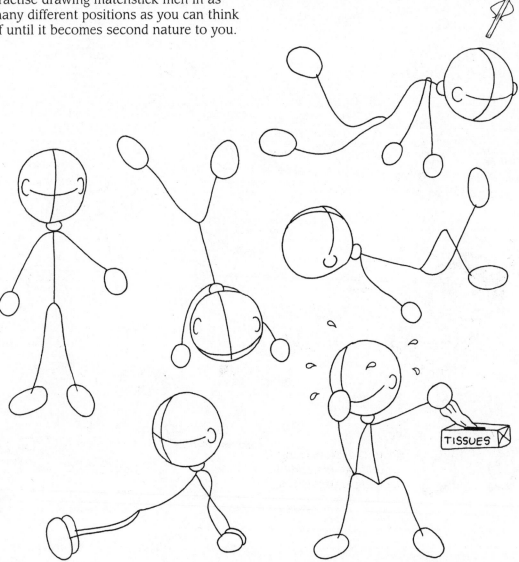

TISSUES

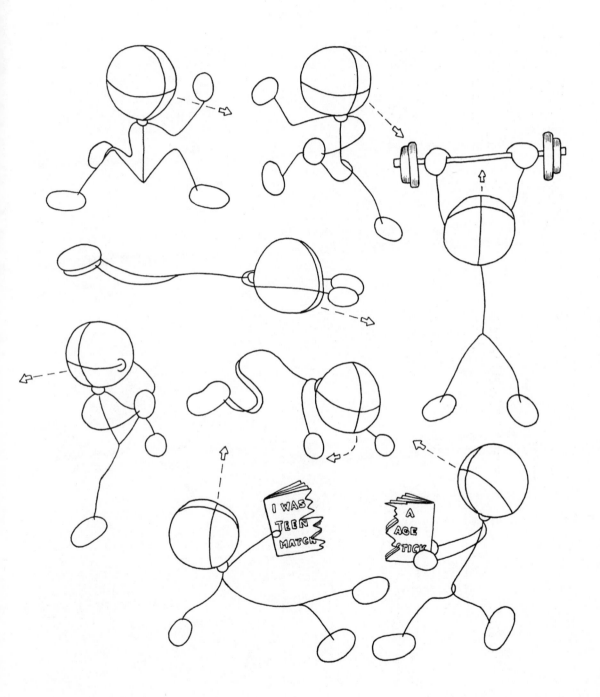

Build That Body

Right, enough of the easy stuff, let's get some bodies together! Start off with your matchstick man and then draw the rest of the body around it (using the technique shown earlier). Don't worry about clothing it yet, for now simply concentrate on getting the positions right.

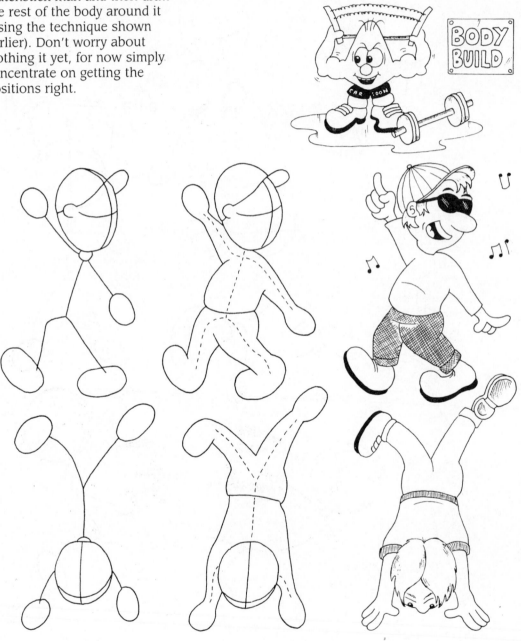

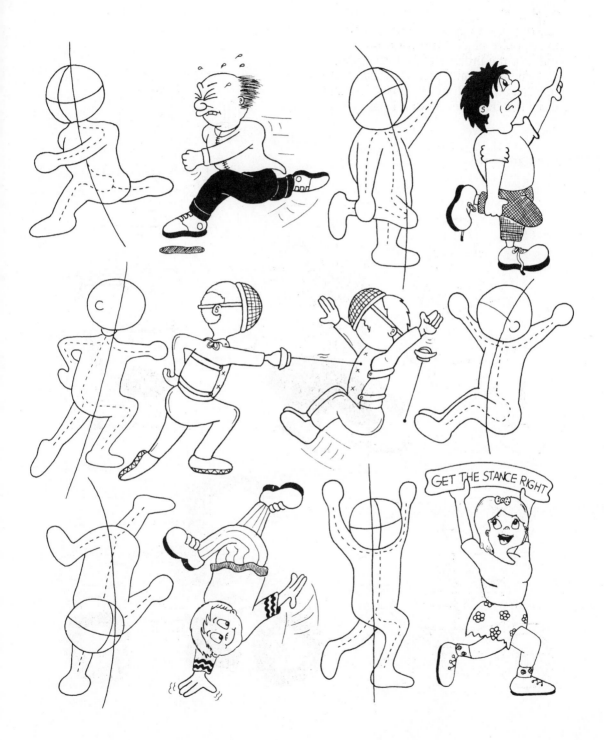

Get The Picture

The next stage is to learn how to incorporate objects into your drawings (refer to the props section in the book).

When involving your characters with objects, always draw the object first and draw the character around it last.

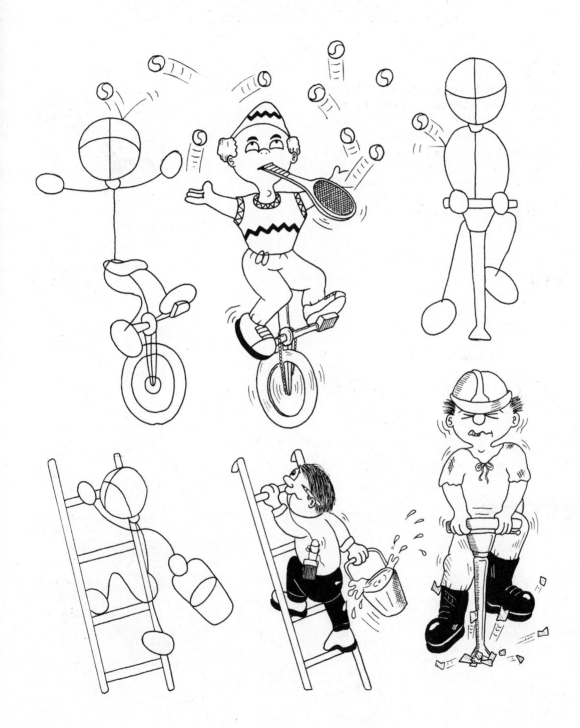

GET DRESSED

You need to be able to draw clothes for two good reasons: to keep all your cartoon characters from catching a chill and to keep them out of prison for indecent exposure! A cartoonist gives the impression of clothing by separating parts of the body (such as the waistline) and drawing in simple patterns or shading in certain areas (normally the trousers).

TOP

BOTTOM

Draw the clothes slightly proud of the body.

I JUST CAN'T FACE IT!

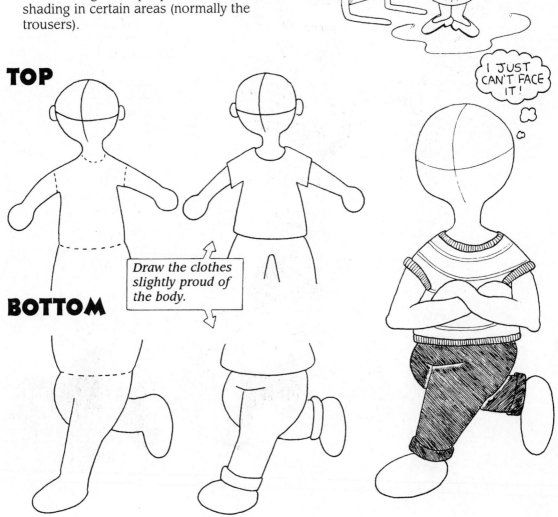

Popular Patterns

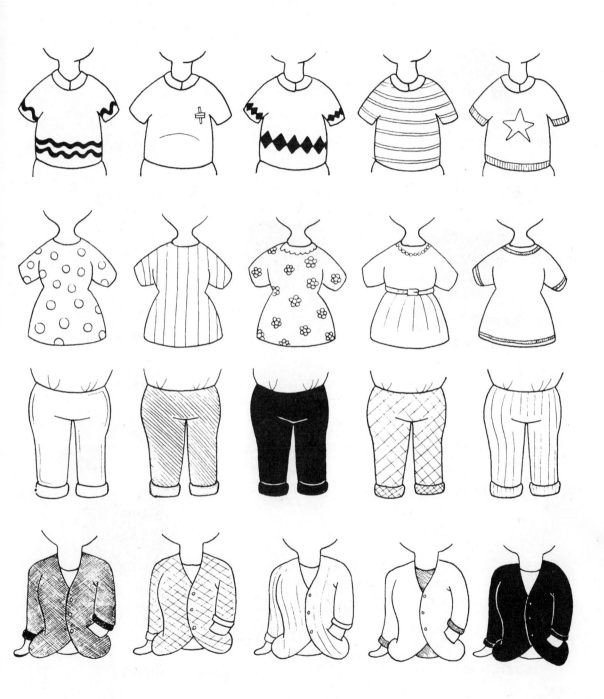

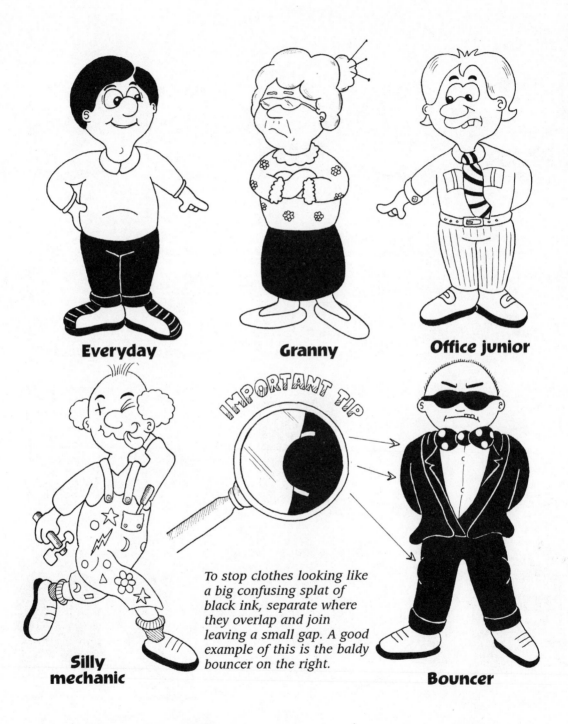

Everyday

Granny

Office junior

IMPORTANT TIP

Silly mechanic

To stop clothes looking like a big confusing splat of black ink, separate where they overlap and join leaving a small gap. A good example of this is the baldy bouncer on the right.

Bouncer

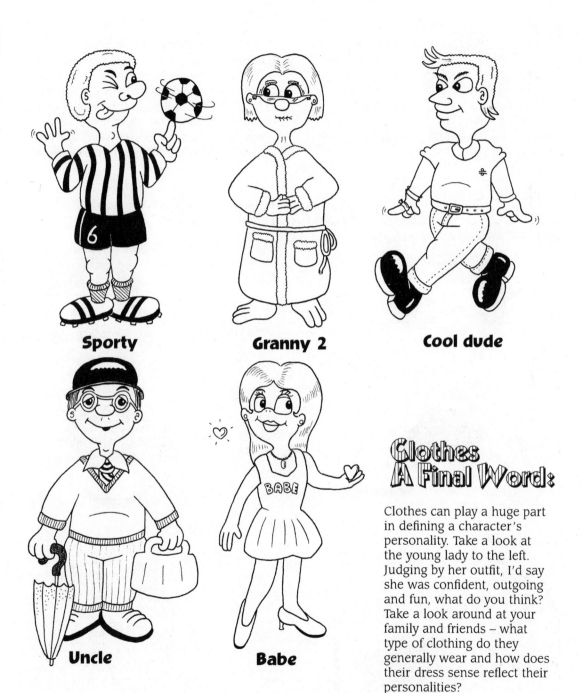

Sporty

Granny 2

Cool dude

Uncle

Babe

Clothes A Final Word:

Clothes can play a huge part in defining a character's personality. Take a look at the young lady to the left. Judging by her outfit, I'd say she was confident, outgoing and fun, what do you think? Take a look around at your family and friends – what type of clothing do they generally wear and how does their dress sense reflect their personalities?

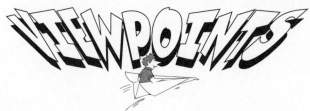

VIEWPOINTS

So far, all of the cartoon characters we have seen have been drawn from a set viewpoint, that is to say, everything has appeared the same distance away.

Imagine if you were to look up at someone whilst lying on your back, the person's feet would seem huge because that is the part closest to the eye and the head would be tiny. This is a common technique known as foreshortening which can make your drawings more interesting to look at. Take a look at the drawings below. The examples on the right show how the drawings on the left would look when drawn from the viewpoint of the eye on the left (I hope all that makes sense).

Here's Looking at You

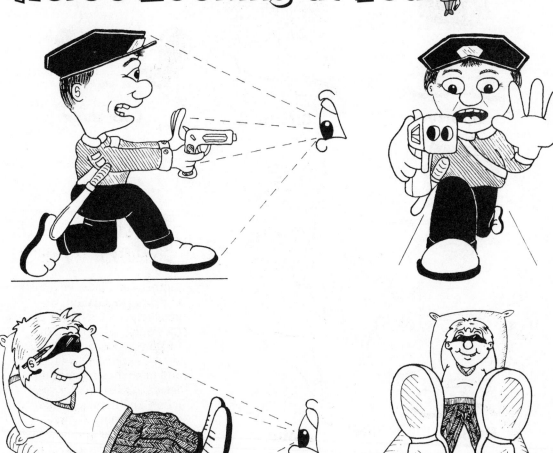

TRY HIGH ANGLES

Head

Body

Legs

Feet

AND LOW ONES

Head

Body

Legs

Feet

THINGS ARE LOOKING UP!

A Vanishing Act

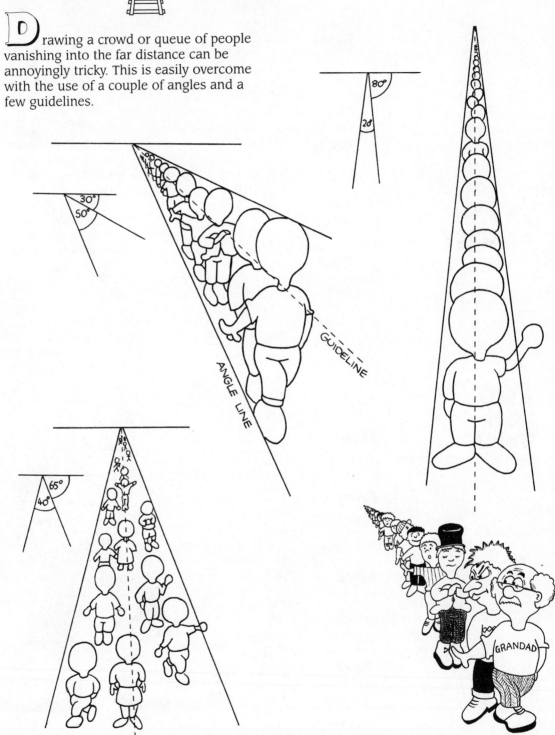

Drawing a crowd or queue of people vanishing into the far distance can be annoyingly tricky. This is easily overcome with the use of a couple of angles and a few guidelines.

80°

28°

30°
50°

GUIDELINE

ANGLE LINE

65°
40°

GRANDAD

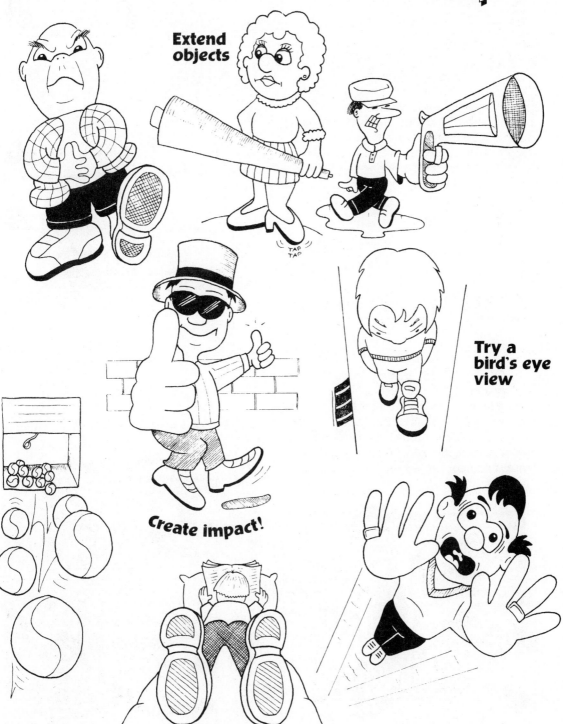

Extend objects

Try a bird's eye view

Create impact!

On the Horizon

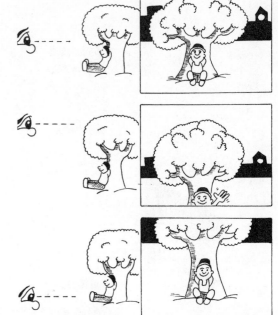

From a standing position, whatever direction you're facing, the horizon will always be central to your scope. The raising and lowering of the horizon line is a trick cartoonists use when the same scene is needed several times over. This method retains the same familiar scene but breaks the monotony. Remember that the higher the viewpoint, the lower the horizon and vice versa.

Get an Angle

Once you have grasped the concept and importance of adjusting horizon lines, the next stage is to combine it with a good angle, thus creating the best view of a scene. The example below shows how this is achieved with the help of a 'rocket camcorder' so that you can see the view.

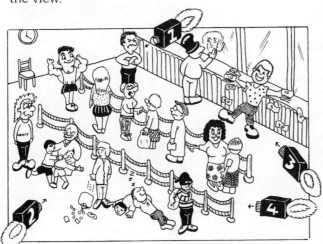

Perspective

Angles, degrees, perspective. These words can normally be found coming out of the mouths of architects and graphic designers, so why would we supreme cartoonists wish to associate ourselves with such mundane vocabulary? Most people tend to draw a scene 'full on' with a central horizon line. This is not a mistake, there's nothing wrong with it, but a drawing can be greatly improved with the use of a few devious angles. The example below demonstrates how a different perspective can really pack a punch to the storyline.

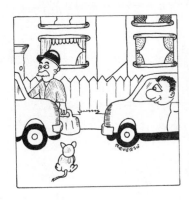 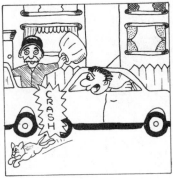 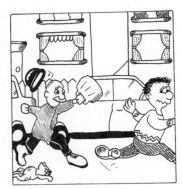

This scene contains way too much irrelevant detail. It looks messy and cluttered. Attention should be focused on the inevitable event.

The main action here (the crash) is the highlight and should dominate the scene.

The reactions of both characters need to be emphasized here using a close up (don't forget the cat).

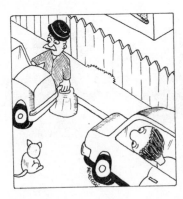

Now that we know how to create and draw cartoon characters, we need a little world for them to inhabit. Scenery is extremely important, without it our characters would all be simply floating in space. There are four main elements that go into building a full outdoor scene: horizon line, sky, land and detail (detail being a few props and, of course, the characters). A scene may well consist of just one simple prop such as a fence or a brick wall. Maybe a full scene is needed with mountains, clouds, grass and trees, but be warned, too much detail can and probably will kill your drawings. In fact, all that is generally required for a good cartoon scene is a simple background with a few well positioned props that relate to the situation.

The Prop

A prop can be a powerful weapon in explaining a story. The two characters above are of average appearance engaged in a conversation, but this is all we know about them. Now take a good look at the identical example on the right. Just by adding a few props and drawing a simple background, we can show that they are returning from a fishing trip and that the far character is half-way through the old 'one that got away' brag.

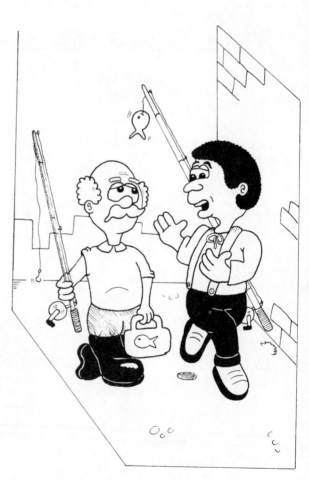

Prop Power

Changing a simple prop in a scene can completely alter the situation! In each of the three examples shown here I've added a different prop between the two characters, creating a new relationship between them each time. For example, a table separating two people would probably depict an important meeting whereas a fence would define them as neighbours. Always try to draw the appropriate scenery for the situation.

A fence for neighbours

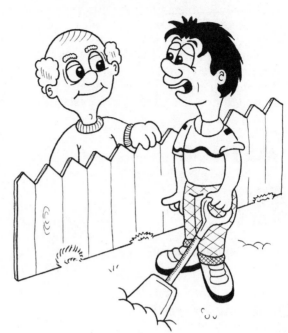

Add a checkout for a customer discussing prices

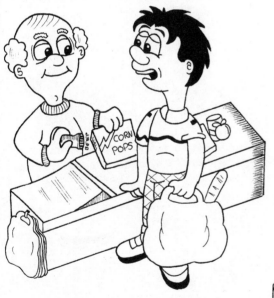

And finally a table for that interview

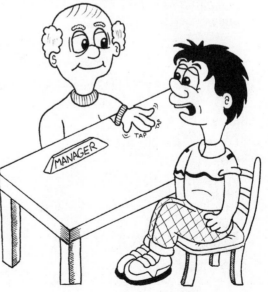

Objects

Everyday objects are absolutely crucial for creating a good scene and atmosphere for your character's surroundings.

Objects in a scene should be kept simple and few, you don't want your drawings to look messy and cluttered, although there are some cartoonists who prefer to flood their work with detail and produce some excellent results. Experiment by finding what suits you best.

There are literally zillions of different objects on our beloved planet. If you learn the basics of object construction, you shouldn't have any trouble.

METHOD

1 Start off by roughing out the basic shape of the object lightly in pencil.

2 Carefully trace over the pencil with your ink pen.

3 Once the ink is completely dry, erase any remaining pencil lines.

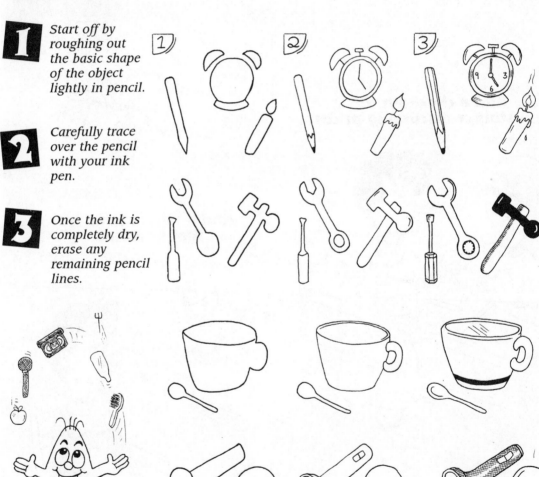

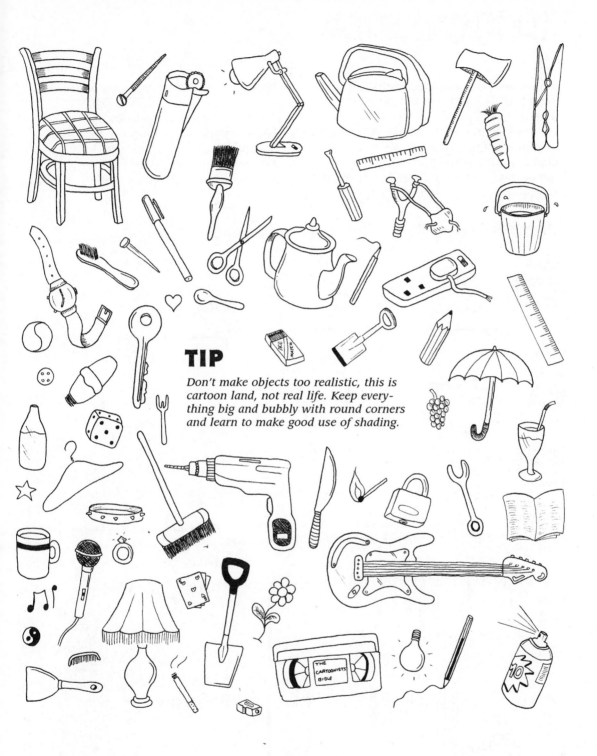

TIP

Don't make objects too realistic, this is cartoon land, not real life. Keep everything big and bubbly with round corners and learn to make good use of shading.

Tricky Props

Have you ever tried to draw a simple object but failed dismally again and again? You might seem to have a crystal clear image in your head of what it looks like but getting it on to paper is an absolute nightmare! This normally happens when drawing really easy peasy things such as trees and fences. So what's the solution? OK, for starters, always build your object up from a skeletal structure. This makes life so much easier (as you'll see from the following examples) but if you still have problems then find a picture of what you're trying to draw and use that as a guide.

Tree

Door

Fence

Barbecue

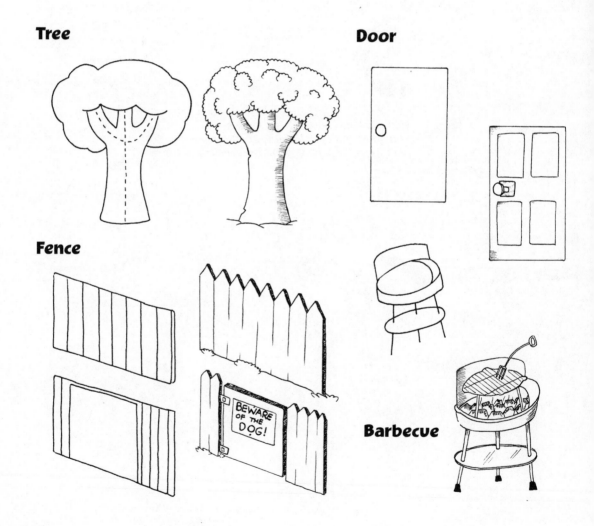

IN THE LOUNGE

IN THE KITCHEN

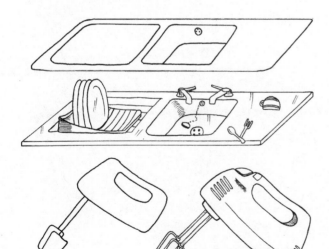

IN THE BATHROOM

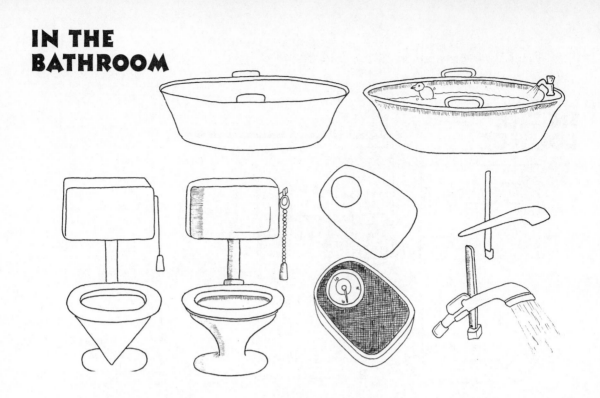

AND FINALLY . . .
IN THE SHED

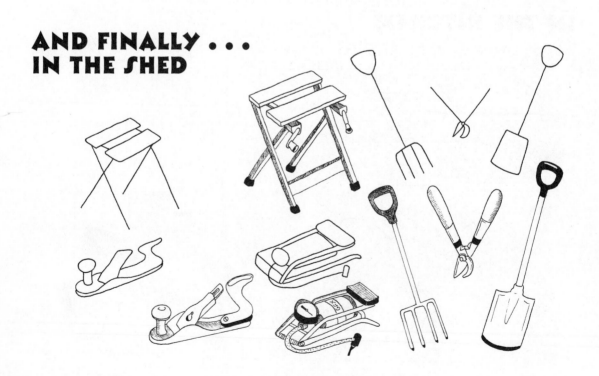

Dashes 'n' Splashes

Can you draw something that is completely transparent? Of course you can! How? Easy. Drawing small, sharp adjacent dashes can give an object a reflective appearance. This technique can be used for glass windows, ice and even metal! Water can be shown by drawing squiggly lines close together.

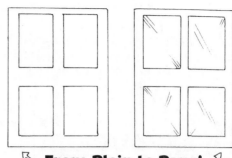

↖ From Plain to Pane! ↗

Glass

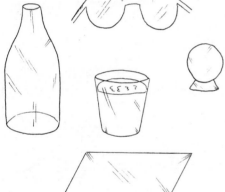

Ice

Metal

Water

DRIPS ←

LET'S BUILD A SCENE

Drawing a scene is only as difficult as you make it! The easiest procedure is to first visualise the whole scene in your head. From here the layout can be planned to determine where everything will go, and finally all your cartoon characters, props and fine detail can be drawn in. Let's start with the back garden.

1 LAYOUT

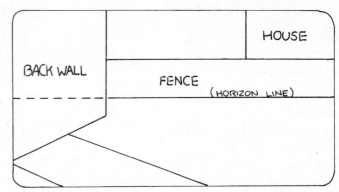

The horizon line basically separates the sky from the land but where it is placed determines the perspective angle of the whole scene. Once this is established, start slotting in the structural elements such as buildings, fences, trees and footpaths.

2 DETAIL

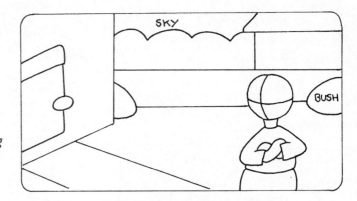

Detail can range from an empty bean tin to an overflowing dustbin. In other words, absolutely anything can be regarded as detail. Decide what everyday objects are needed and place them into your scene along with any characters.

3 BLACK & WHITE

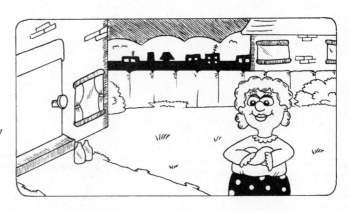

Once the scene is complete, you will need to make good use of black and white (just like a zebra) otherwise it will look like a page from a colouring book. Try not to overdo it or you'll kill the drawing: just decide what areas need to be blacked out and then ink them in.

Here's One I Did Earlier

SWIM FOR IT!

DESERT ISLAND

Detail

Palm Tree

Shark's Fin

Sinking Ship

Signpost

Bottle

Layout

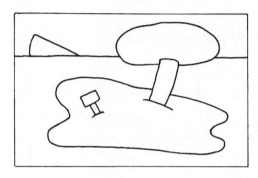

Complete

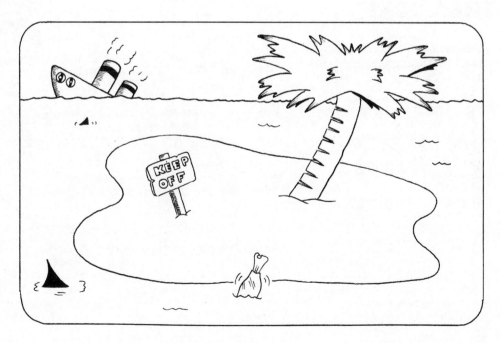

Try These For Size

BOY'S BEDROOM

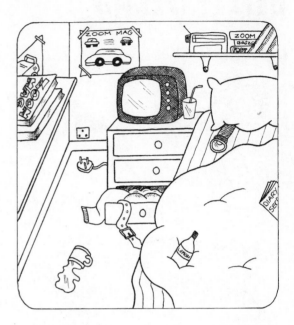

THE LOCAL

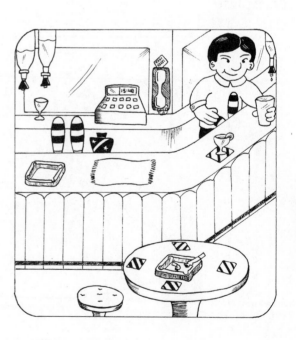

SPOOKY WOODS

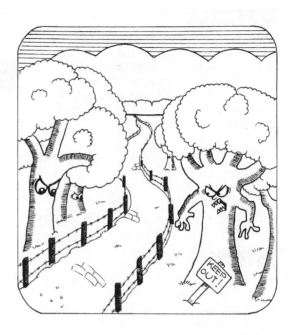

A STREET

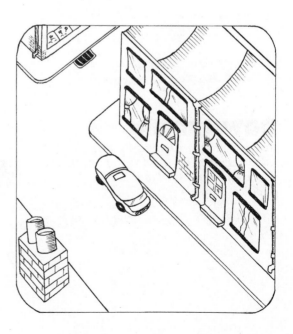

Sunshine and Showers

DRIZZLE

A few diagonal dashes can be used for light rain (or straight down if you so desire – experiment with both). Take note of how the rain is splashing off the character's hand, also a cloudy silhouetted background is a good setting for drizzle.

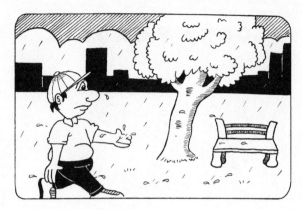

SNOW

Brrrr, roll on summer. Snow is probably the easiest weather condition to draw. Small circles can be used for the snowflakes and basically just leave everything white but don't forget to add a snowman to the scene.

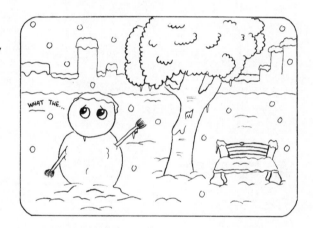

DOWNPOUR

Heavy rain is virtually the same as light rain, only heavier (obviously). Triple the dashes and splashes and draw in a few puddles.

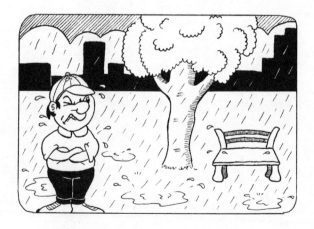

WINDY

Whoops, there goes the cap. Wind can't actually be seen but it can be shown using various techniques. The most common method is having various objects flying around – even the top of the tree is joining in the blustery action.

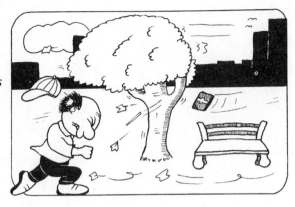

SUNNY

Now this is the life. Plonk the sun anywhere in the sky, add a few 'heat lines' at random around the scene (with a few radiating from the sun) and we have a beautiful summer's day. The two children playing ball in the background also help to show that it's hot out.

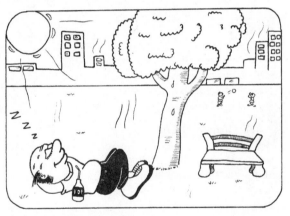

& STORMY

Oh dear, this is definitely a nice hot cup of tea in front of the box day. The bench has been literally exploded by a lightning bolt, with a heavy downpour complementing the effect.

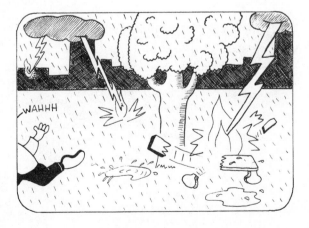

Fight Clouds

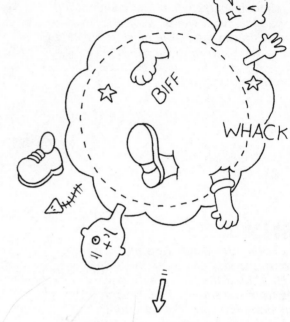

If two cartoon characters have a difference of opinion, they could sit down and talk about it or they could, well, bash the hell out of each other. Invent some of your own fight clouds, they're fun to draw and are a great addition to any scene.

 Draw a circle.

 Sketch out a curvy perimeter around the circle as if you were drawing a large sunflower. From here, start to map out the detail.

 Absolutely anything can be thrown into your fight cloud. This one seems to have a fish bone flying from the scene (makes you wonder what's going on behind that dust – the mind boggles). Make sure you draw in a couple of strained cartoon heads and remember, lots of action and speed lines are essential.

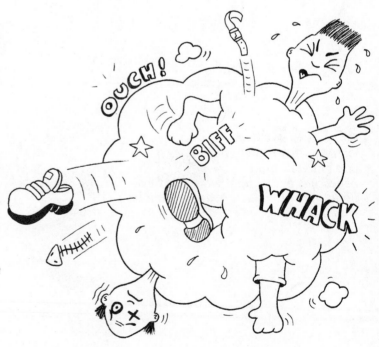

Dynamite

BLAM! Explosions are very popular in cartoon land. From atomic destruction to a slight boom, an explosion always goes down well in a scene.

 Start with one of the shown starting shapes, or create one of your own.

 Start to build the explosion out of the shape. Nice straight lines are the most effective so use a ruler.

 Believe it or not, explosions are best drawn neat, tidy and, in some cases, symmetrical. A smartly drawn explosion comes across more powerfully than one drawn willy-nilly.

Mushroom

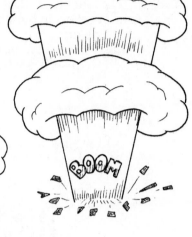

Cross blow

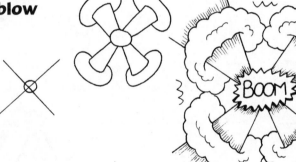

Distant sunrise

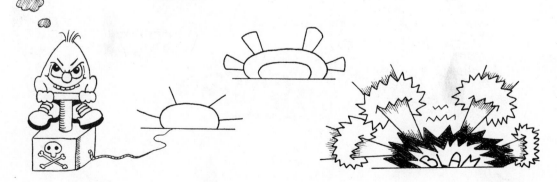

WACKY WRITING

Wham, Bam, Kazam! If you want your drawings to have more impact, then cartoon writing is an excellent option. Cartoon writing can be used for titles, character speech, special effects and much more. Try to invent some of your own styles. If you become really good, then maybe you could embark on a career in signwriting in the future if you want to.

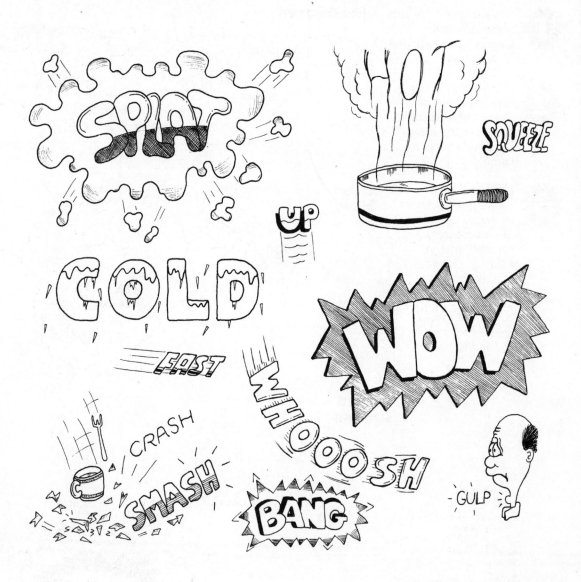

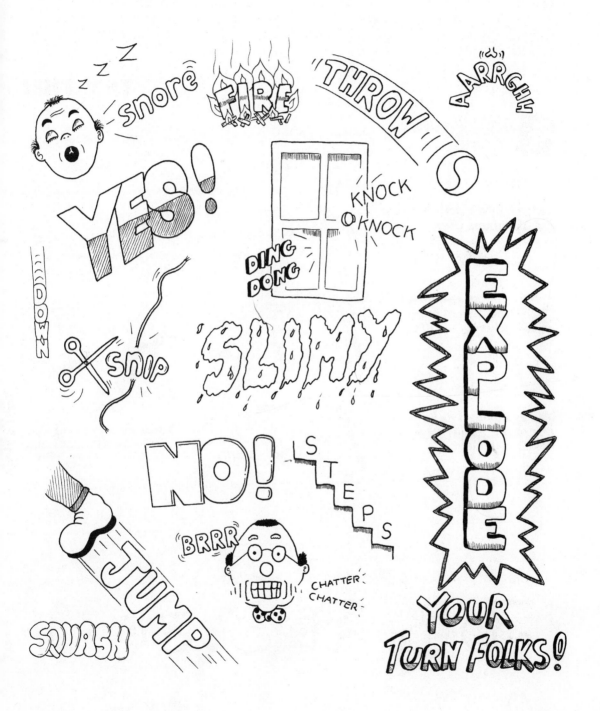

It looks dynamic, is totally cool and it is one of the most popular lettering designs used amongst artists, advertisers and, of course, cartoonists. What is it? It is known as three-dimensionally projected imagery (or 3D to us non-profs).

To learn how to give lettering this solid effect, a basic understanding of angles will help no end. (Don't panic, I do mean basic.)

TRY THIS

 1 *Start with some big, bold letters.*

2 *Draw a perimeter line around them.*

3 *Cut out the angles for the desired direction (this is the difficult bit).*

4 *Finally, block the sides with black for a solid look.*

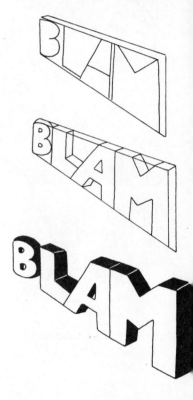

Up/right	Down/Left	Up/left	Down/right	Shadow	Bevel

84

Cartoon writing is limitless. There are many hundreds of popular designs technically known as typefaces or fonts. My two favourites are the double bubble and the flame thrower on the right. Give these two a go, then create some of your own, but don't forget to give each one a snazzy name.

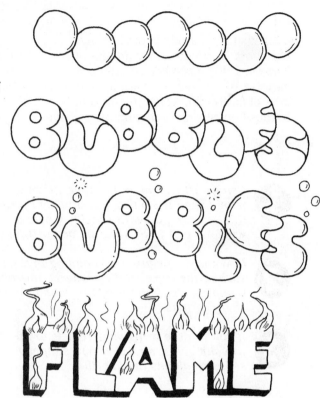

SHADING

Once you have learnt how to create basic, solid words, the next stage is inking them in such a way that they stand out from the page instead of looking empty and hollow.

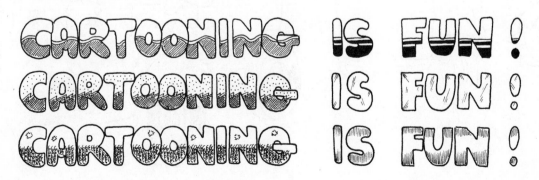

TOONY TRANSPORT

et's take a look at some toony transport. It is a great advantage for a cartoonist to be capable of drawing cartoon-style vehicles. You may find this area of cartooning very difficult (I did) because objects like cars and buses have a lot of detail to them and look totally different from various angles, but the key to getting it right, as with anything, is practice. An excellent tip is to buy a toy vehicle and use that as a guide to get the angles right.

1 *Using a ruler, map out a three-dimensional box with a slightly smaller one directly in front of it. From here, draw in roughly where the windows and wheels should be positioned.*

2 *Now the fun begins. Start adding in the detail such as the wheel arches, wheels, mirrors, bumpers, etc. Don't forget to round off any sharp corners.*

3 *If you want to bring your vehicle to life, then why not give it a face? If not, simply draw in some headlights and a grille.*

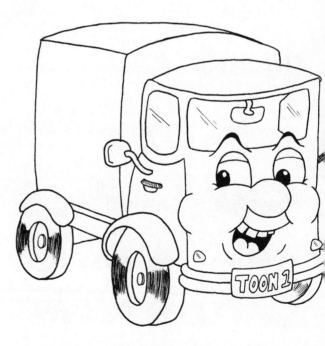

AEROPLANE

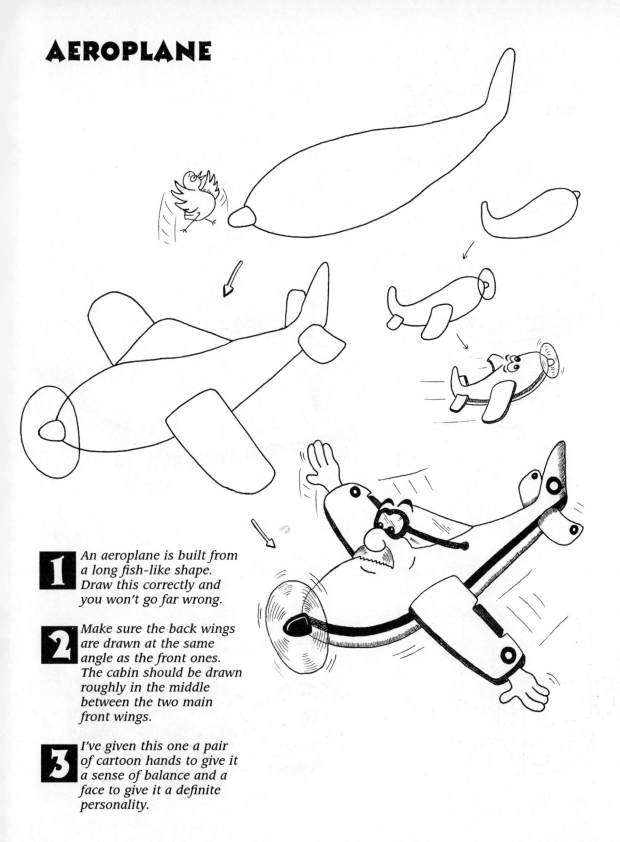

1 An aeroplane is built from a long fish-like shape. Draw this correctly and you won't go far wrong.

2 Make sure the back wings are drawn at the same angle as the front ones. The cabin should be drawn roughly in the middle between the two main front wings.

3 I've given this one a pair of cartoon hands to give it a sense of balance and a face to give it a definite personality.

Mini

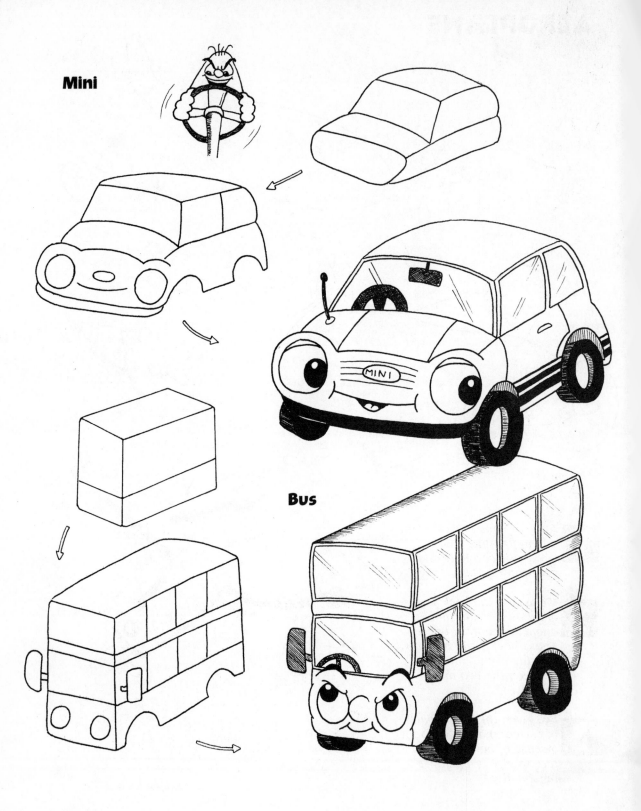

Bus

Boat

Forklift truck

Chopper

Tank

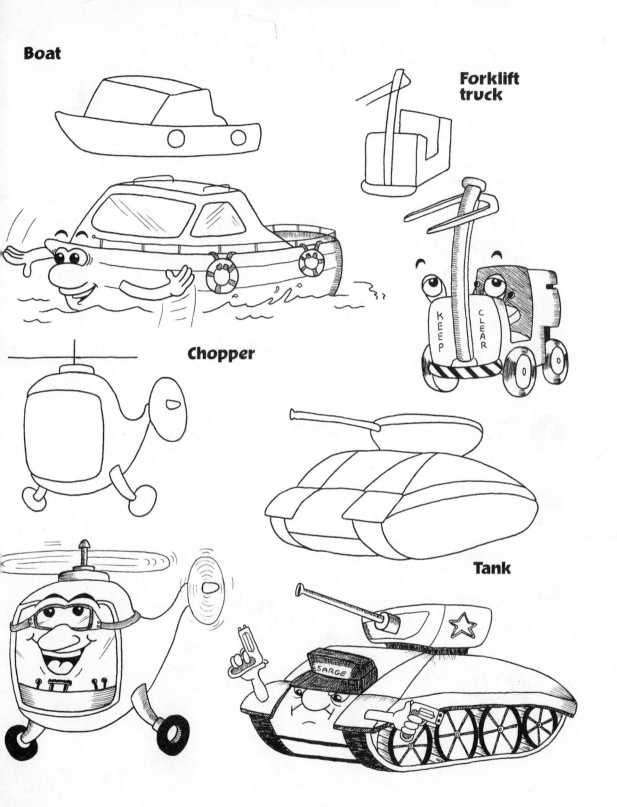

TOONY OBJECTS

Learning to draw normal objects as cartoon characters can give a really special touch to your talent. Cartoon objects can have just as much personality and individuality as human characters.

Take the Magic Carpet from *Aladdin*, it has no arms, legs or face, it is drawn as a basic carpet (with a nice pattern) yet the way it has been animated gives the impression that it is alive and real; you can even tell what mood it is in!

Every object, from a bone to a baseball bat right down to the infamous kitchen sink can easily be transformed into a cartoon character with any personality you choose.

 Sketch out the object that you want to transform.

 Draw on a face and add some arms and legs.

 Give it a name, decide on a personality and Hey Presto! . . . cartoon object.

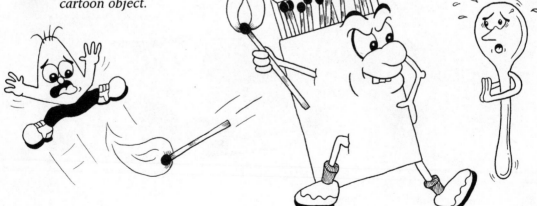

90

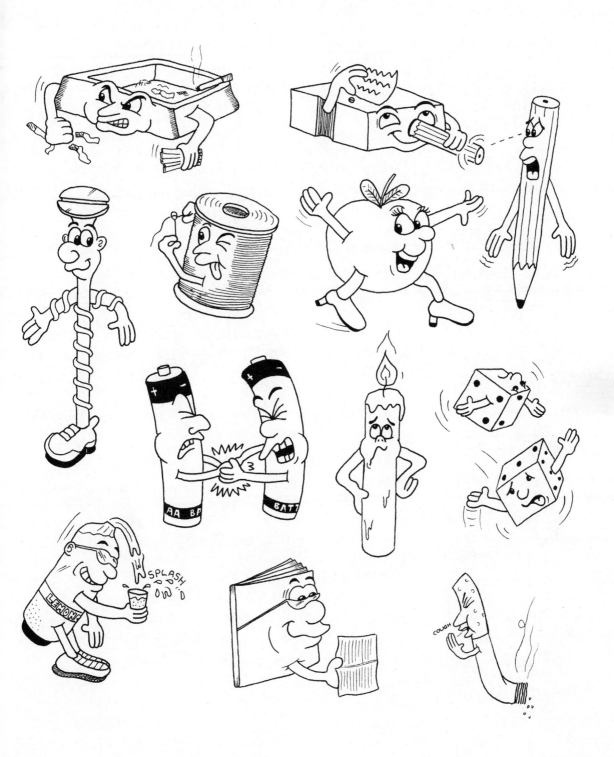

Personality

Creating cartoon objects is all well and good but without a personality or something special about them they are nothing more than a good drawing. Design an object. Sit back and drift into deep thought.

What is the object used for? What is its purpose? Does it involve other objects? Take advantage of why the object was invented and twist this information into the drawing to create an amusing personality within your object.

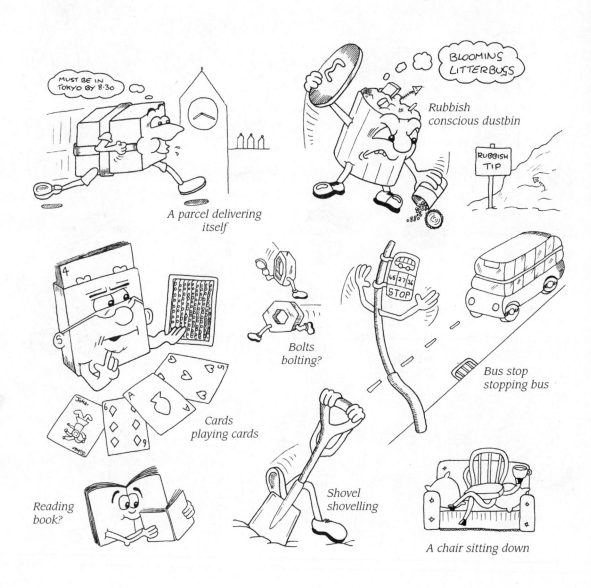

A parcel delivering itself

Rubbish conscious dustbin

Bolts bolting?

Cards playing cards

Reading book?

Shovel shovelling

Bus stop stopping bus

A chair sitting down

Families

Cartoon object families are a great asset to any cartoonist. Think of an object and how many different styles and shapes there are of it. These can then be transformed into mummies, daddies, uncles, grannies, not forgetting the mother-in-law. Even the shape of an object can sometimes determine what character it should be!

Tooltoons

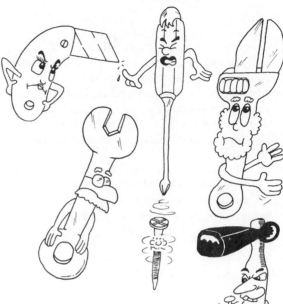

Phonetoons

Toonshades

ANIMALS

Animals play an incredibly huge role in cartooning! There are areas in cartooning that are completely dominated by animals (especially animation). Think of some of the biggest and best known Disney films such as *The Lion King* and *101 Dalmations,* not forgetting *Lady and the Tramp*, all of which have animals as the stars.

There are problems with drawing animals. Unlike human characters which are all built from a similar structure (the matchstick man), animals are much more complicated as they vary enormously in shape and size. For example, if you know how to draw an elephant, it won't help you in the drawing of a giraffe or a baboon. The construction of animals differs from what you have already seen but even so, they are still all built from their own skeletal structures.

A lot of animals in cartoon land wear clothes. This is an advantage because, more often than not, the cartoonist can get away with giving the animal a human figure, thereby doing away with the awkward animal bodies.

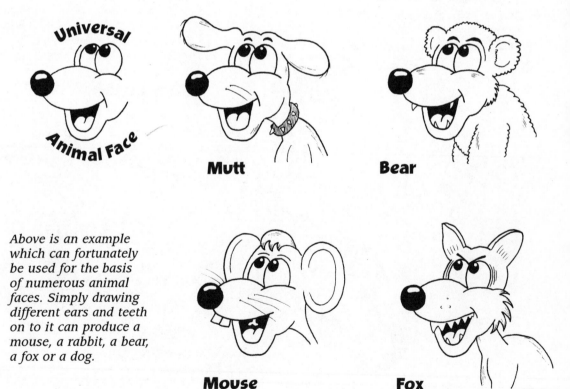

Universal Animal Face

Mutt

Bear

Above is an example which can fortunately be used for the basis of numerous animal faces. Simply drawing different ears and teeth on to it can produce a mouse, a rabbit, a bear, a fox or a dog.

Mouse

Fox

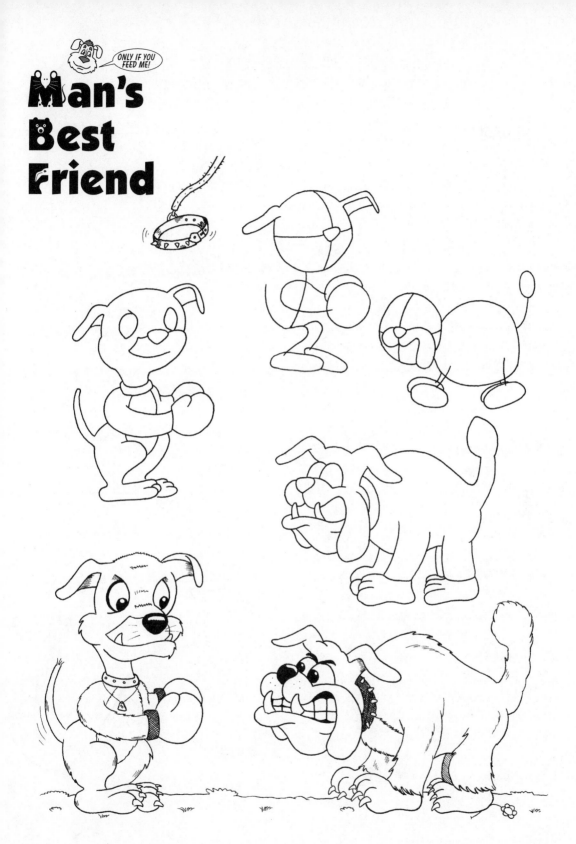

Man's Best Friend

ONLY IF YOU FEED ME!

Mouse

Moggy

Giraffe

Bunny

Elephant

Crocodile

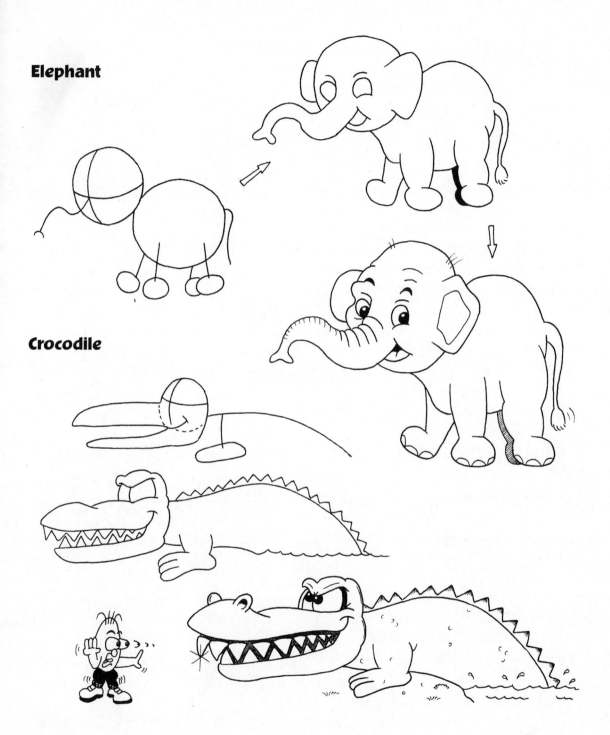

Animals in Motion

Nearly all animals have the same basic body shape and this helps enormously when drawing them in motion. The creature below could be drawn with the shell of anything from a rabbit to an elephant around it.

Build animals up using ovals. This gives a sense of flexibility thus making their movements more realistic.

THE POUNCE

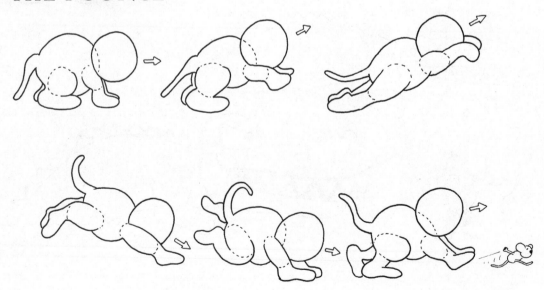

Wings

Tails & Toes

Probably the most difficult animal movement to master is that of a bird in flight.

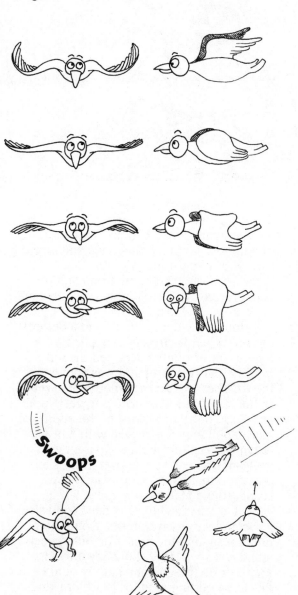

Swoops

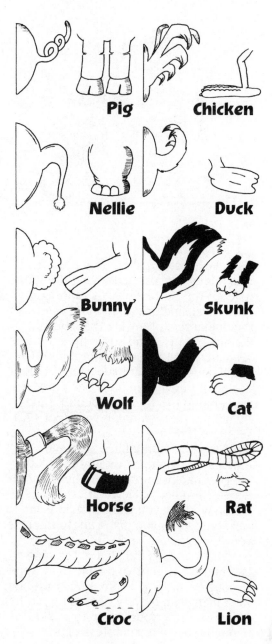

Pig

Chicken

Nellie

Duck

Bunny

Skunk

Wolf

Cat

Horse

Rat

Croc

Lion

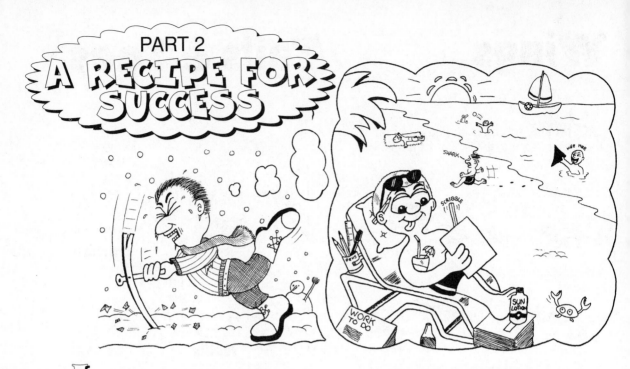

PART 2
A RECIPE FOR SUCCESS

I left school when I was a mere pup, 14 to be exact. I had no qualifications and was totally clueless as to what the future held for me; all I knew was that I could draw. Realising this at an early age was the one aspect of my life that showed definite promise, and so an artistic career seemed to be the most natural path to travel down. It could have been graphic design, it might even have been modern art painting (perish the thought), but thankfully, cartooning prevailed. At 17, I set myself the first of many goals – to get a picture joke printed in a national newspaper – and just two months later my goal had been scored. I knew what I wanted and had achieved it.

So what do you want to gain from cartooning? Do you just want to impress your family and friends or impress the world? How does the idea of bringing laughter to millions of people daily appeal to you? Cartooning is fun and cartooning for a living can be very rewarding but first you must bring yourself up to a good enough level to turn professional.

There are two main ingredients that go into the recipe for success: talent and determination. Don't worry if at present your drawing ability couldn't exceed that of a hoofless donkey, this book will take care of that (trust me), but the determination must come from within you, only you can strike the match to start your ambition burning!

I found the determination just before my seventeenth birthday; I applied for a job but unfortunately received the job from hell. It was winter, it was snowing, the weather was so cold that I could read in the air what I was saying! It was 6 a.m. and dark, but there I was, in the middle of a grim building site, armed with a heavy duty pick axe, digging an apparently irrelevant hole for some over-enthusiastic crazy foreman. This might sound like a scene from a chain-gang movie but it wasn't, it was my life. One day I took sick leave and sat in my parents' living room, fire blazing and tea maker on emergency standby. I spent the whole day drawing and kept on imagining what it would be like to be getting paid for those drawings instead of receiving regular frostbite treatment. This thought gave me the push to concentrate all my time and effort into

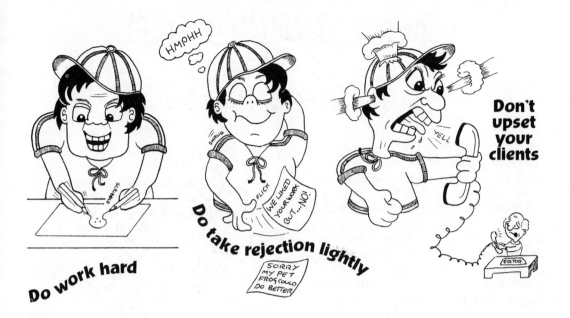

Do work hard

Do take rejection lightly

HMPHH

SHRUG

FLICK

WE LIKED YOUR WORK BUT ... NO!

SORRY MY PET FROG COULD DO BETTER

YELL

EDITOR

Don't upset your clients

becoming a professional cartoonist. I quit my job the next day and have never looked back, so if I can do it then so can you!

But be prepared for some hard work. The cartoonist market is a very tough and competitive one with hundreds of budding artists trying for fame and fortune. You will find yourself sacrificing weekends to meet important deadlines, you will have to learn to swallow rejection and spit it straight back out and much more. I'm not in any way trying to put you off, I'm simply being realistic because success won't come knocking at your door unless you invite it to through hard work.

A vital point to remember (which you will eventually find out for yourself) is that cartooning is as much a business career as it is an artistic one: after all, once your work is complete you need to sell it to the potential clients. If you are shy or simply not very good at talking to strangers, then hire some books on assertiveness and confidence-building, not forgetting business skills; your business sense has to be as sharp as your

wit – it's not a nice experience getting 'ripped off'.

Once you do start to get clients, treat them with the utmost respect: it doesn't matter what kind of people they are, the bottom line is they are paying your wages. Always keep the client happy. If you are asked for two or three examples, do four or five instead! A happy client usually turns out to be a regular client with as much respect for you as you have shown for them and if they (or any others) do reject your work, don't ring up demanding an explanation – it's annoying and it's unprofessional. Just accept it.

Now the rest is up to you, go for it aggressively, full steam ahead and let nothing stand in your way!

GO FOR IT GO FOR IT

ESSENTIALS
Getting Started

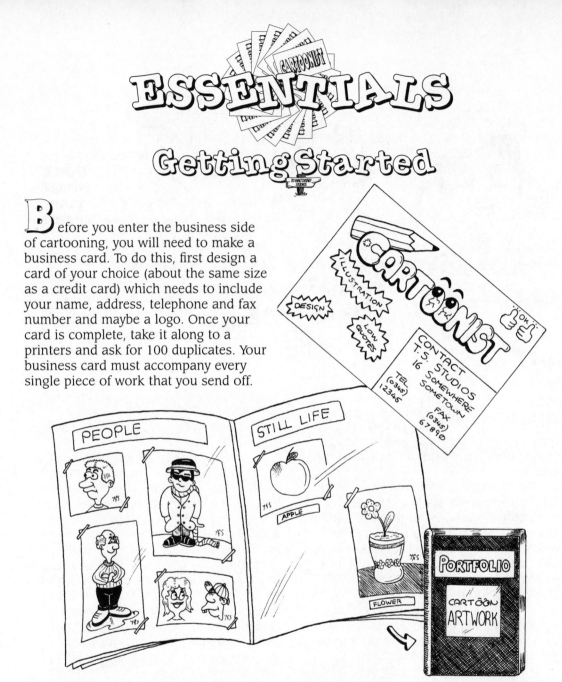

Before you enter the business side of cartooning, you will need to make a business card. To do this, first design a card of your choice (about the same size as a credit card) which needs to include your name, address, telephone and fax number and maybe a logo. Once your card is complete, take it along to a printers and ask for 100 duplicates. Your business card must accompany every single piece of work that you send off.

Every good artist needs a comprehensive portfolio to show potential clients the level of their work and what they are capable of. Flood your portfolio with your best work, your favourite sketches and anything else that you feel like adding.

Whatever you do, don't just throw all of your drawings into an envelope and pass it off as your portfolio: presentation is very important if you want to impress!

Buy an A4-size clear pocket folder with a leather exterior for a really professional look. This can be your master copy which never leaves your side. For duplicate and spare portfolios (for posting your work), photocopy your work and buy a cheap ring-binder. This way it won't be a personal disaster if your work gets lost in the post, thrown away by a nasty editor or leaves for the foreign legion.

102

File It

If I asked you to draw a sixteenth-century knight standing beside a mediaeval castle, your waste paper basket would probably fill up quite rapidly.

There are so many objects and uniforms around that a cartoonist would be at his wits' end (or pencil end) trying to perfect a drawing of some thing that he had only briefly, or maybe never, seen before. That is why from today, this very moment, I want you to start building up a huge bottomless collection of pictures of everything from a footballer's shirt to a forensic scientist's scalpel (don't get over enthusiastic and hold your local library at gunpoint).

Collect pictures of interest or shots of anything that you might find useful from magazines, catalogues, newspapers or even your next door neighbour's latest romantic novel! Keep your pics in a filing cabinet or a set of drawers so that in a year from now, if you are in need of a certain picture to draw, you won't have to hunt about, you'll already have it! Your filing cabinet will become an essential piece of equipment: in it will be stored all of your work, your portfolios, lists of clients, back-up jokes and much, much more. Treat it as the centre of your universe.

Go For It!

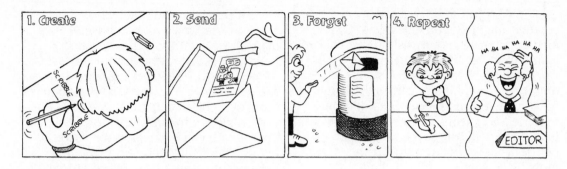

NEVER GIVE UP

Starting to get your name established in the cartoon world can be very frustrating and disheartening. You may not get anything published for many months. Don't let this put you off, just remember the 'P' in published stands for persistence! This advice is not just for pocket jokes, it also applies to comic strips, greeting cards, illustration work and almost every other area of freelance cartooning, but whatever the case may be, as the title says . . . 'Never Give Up'!

- *Always sign your work. A small signature will do. It's your creation, be proud of it.*

- *With pocket jokes, keep detail to a minimum; only draw what is needed to illustrate the scene.*

- *A good joke with a bad drawing will sell, but not vice versa.*

104

Freelance (The Open Market!)

Cartooning can brighten up the advertising area of almost any business and organisation, from a building society's promotional leaflets to a music company's record sleeve.

The first step to obtaining freelance work is to let people know you exist! Design a small flyer in black and white (with a colour brochure in mind for the future) advertising your services. Get as many duplicates as possible and send them to any companies that you think would be interested in brightening up their image. Through experience, you will learn what types of companies are potential clients.

Try places that deal with T-shirts, – matchboxes, beer-mats, balloons, cups, etc., not forgetting banks, building societies and even supermarkets. The *Yellow Pages* is an excellent book for selecting customers. If you get a good feeling about a certain company, then why not send them some samples of your work along with your flyer? This could improve your chances no end!

One last thing, always address your mail to the company's Director of Advertising as this is the person you need to target.

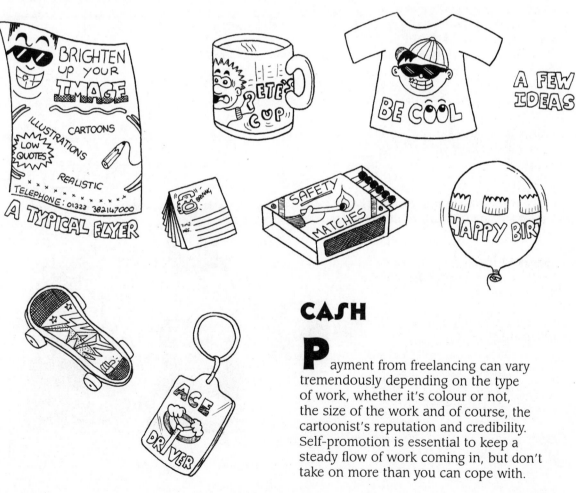

CASH

Payment from freelancing can vary tremendously depending on the type of work, whether it's colour or not, the size of the work and of course, the cartoonist's reputation and credibility. Self-promotion is essential to keep a steady flow of work coming in, but don't take on more than you can cope with.

POCKET JOKES

If a keen driver dreams of taking the chequered flag in Formula 1, then he or she should start with something less challenging such as go-cart racing. In the same way, if a keen artist wishes to take the cartoon world by storm, then they should start with pocket jokes or simple comic strips.

Pocket jokes are everywhere, from the boss's post-it notes to the office calendar, not forgetting greeting cards, T-shirts, beer-mats, matchboxes and countless other places. There seems to be no escaping this welcome plague of humorous illustrations!

Method

Draw your pocket jokes on to thin white card, draw a frame about 5 in x 3½ in (12 cm x 8 cm) to fit round the gag.

Clearly write or print the punchline underneath or alternatively use a speech bubble.

Get together approximately 10–15 finished samples.

Post to local and national newspapers and magazines. Don't forget to enclose a stamped, self-addressed envelope.

Once posted, forget about them and plough straight into the next batch.

CARDS

G reeting cards seem to be a step up from pocket jokes though not as high profile as comic strips but nevertheless can still provide a steady income if your work is good and becomes popular. Putting together a card, whether it is for a birthday, retirement, new job or special occasion, is very similar to creating a pocket joke, putting aside the fact that greeting cards are normally in colour – depending on your style! There have been some extremely successful ranges of black and white cards by certain cartoonists. Why not try to design a completely unique style or your own? You never know, it could make you famous!

• *Think up a good gag relating to the situation. Remember that in most cases, the punchline is actually inside the card.*

• *Draw up between 10 and 15 samples. These can then be coloured using water colours or pencils.*

• *Send off your work in a padded envelope (in case the jokes are mad), including your business card. Mail your work to several greeting card companies.*

• *Once sent, forget about them and plough into the next batch.*

107

BOOKS

Regular work can be found through illustrating children's books but be warned, most companies that deal with this type of work prefer drawings to have a realistic edge to them. Send a copy of your portfolio to as many companies as possible that write children's books. If an editor likes your work, you will be given a contract stating the work required along with any deadlines and terms of payment.

FIRST

The editor will explain exactly what is required of you, for example, if the work needs to be in black and white or colour, realistic or cartoony and the size of the illustrations. Show initiative by adding your own suggestions: remember, you're the professional.

AND THEN

It will then be up to you to transfer the ideas to paper. Don't overdo the drawings with detail or make them too complicated especially if the book is directed towards young children. Simple drawings suit simple books.

COMIC STRIPS

Comic strips are loved throughout the world with most newspapers and magazines running them daily. A successful comic strip can earn its creator millions of pounds, although this is rare – but not impossible. Unlike pocket jokes, comic strips are usually a continuously running story which must always keep up the humour or action otherwise it will get boring and eventually fail.

WHERE?

Before you sell your work, you will need to know where to send it. A syndicate is a company which will distribute your comic strips (and other work) to newspapers, magazines and collect the payments which are then split between the syndicate company and artist at a percentage (usually 50–50). The more places that publish your work, the more money you will get. A full list of cartooning syndicate agencies can be obtained from your local library.

4 Steps to Publication

1 THE IDEA

The most important part of creating a comic strip does not even require a pen or pencil (apart from jotting down notes). Think: what will the storyline entail? Who are the characters and what are their personalities like? Where is the cartoon set? Is it to be a one-off pun every day or a continuous storyline? For your comic strip to be a success, your idea must be an original one with characters that can provide a lot of humour and popularity! This is not easy and, as I said before, the humour has to be constant to hold the readers' interest otherwise it will fail.

Try ideas and if one doesn't work then fine, try another. Experiment for as long as it takes until you have got a good storyline with distinctive characters that you think will appeal to people. Try to get the honest opinion of friends and family and listen to their personal criticisms and suggestions. Look in newspapers and magazines and learn from them! Do not copy anybody else's work but do take ideas and styles you like and incorporate them into your own comic strips.

Before you start to draw up the actual comic strip, put together a character profile (model sheet) like the one below, describing the stars of the show in detail. The model sheets will accompany the comic strip when it is sent off to the editors.

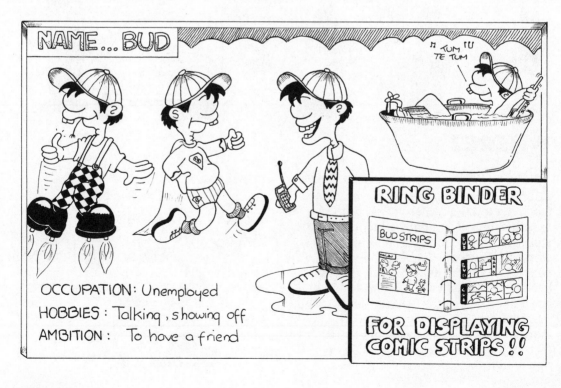

2 THE LAYOUT

For best results, draw your comic strip on to thin white card about 3½ x 12½ in (10cm x 35cm). This is approximately twice as large as it would appear if published. Start by mapping out the lines for the speech and draw the action in rough. From here, add the rest of the drawing in pencil although don't rush through it, go over it a few times to make any necessary improvements.

3 INKING

Using a 0.2 or 0.3mm nib black ink pen, carefully trace over the pencil lines and then, once the ink is completely dry, erase any remaining pencil marks.

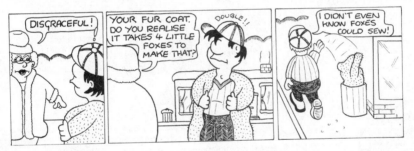

4 SENDING

You now need to draw up about 20 finished samples, making sure that each one is on a separate piece of card with your name and address printed on the back. Take all of your strips to a photo-copier and have each one reduced several times for spares. Take one batch to your bank and get them to put it in a vault indefinitely. Ask for a dated receipt. This will not cost much (about £10 per year) and will protect your work from possible copyright theft.

The comic strips can now be mailed to the syndicates. Make sure that you enclose a self-addressed envelope and your business card. For a professional look, fit your comic strips into a clear pocket ring binder (presentation is important). Once the work has been sent, try to forget about it and get started on the next lot! If you do make a sale, the editor will contact you to discuss payment but make sure you arrange terms that you can live with before breaking open the bubbly.

Speech

As you have already seen, a speech bubble is needed to contain the speaking character's words to avoid confusion as to who is saying what in the drawing. The example below left is the most common and the tidiest speech bubble but other styles can add more impact and emphasize more clearly what the character is saying.

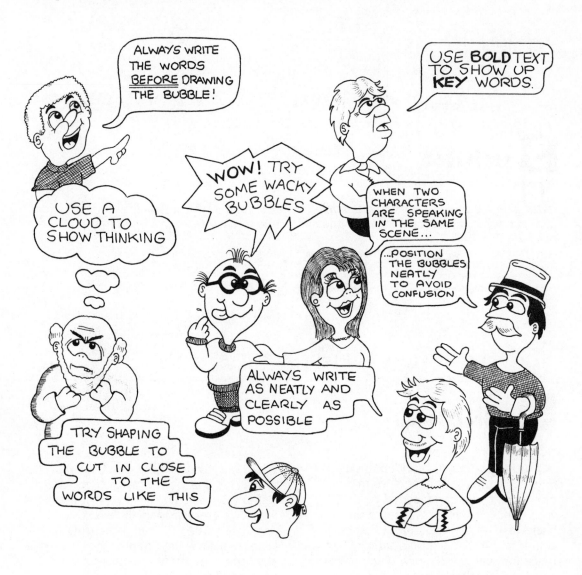

Extras

ow clear is your handwriting? Is it nice and neat or horribly illiterate? Whatever the case, you will need to be able to write neatly for your comic strips and all the other areas of cartooning. The best way to achieve this is simply through good old-fashioned practice!

1 *Map out some guidance lines.*

2 *Write the words in roughly.*

GOOD OLD-
FASHIONED PRACTICE

3 *Finally, ink over the pencil. Felt pens are ideal.*

GOOD OLD-
FASHIONED PRACTICE

STRIP TIPS

Instead of a boring title...

...try something like this!

USE CORNER BOXES TO BRING THE VIEWER UP TO DATE

SUDDENLY

NEXT DAY

AT JIM'S HOUSE

PANEL BREAKERS

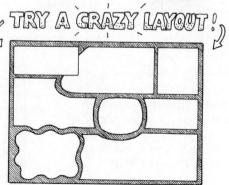

TRY A CRAZY LAYOUT!

COMIC pages

Producing work for comic books is without a doubt my favourite area of cartooning. Not only does it give me the opportunity to push my gag-writing to its full potential, I can also go to town on my artwork. Obtaining this type of work may be quite difficult as normally the studio that produces the comic employs enough artists to cover the work, but it's still worth a try. Create a comic story spreading over one or two pages with a good humorous storyline and fun characters. A comic story usually consists of approximately 10–12 panels per page; the storyline should build to a climax at the end with gags and quirks in between to hold the readers' interest.

Before you begin planning your comic page, study some books like *Beano* or *Dandy* and use them as a guide to the standard of work required in this area of cartooning.

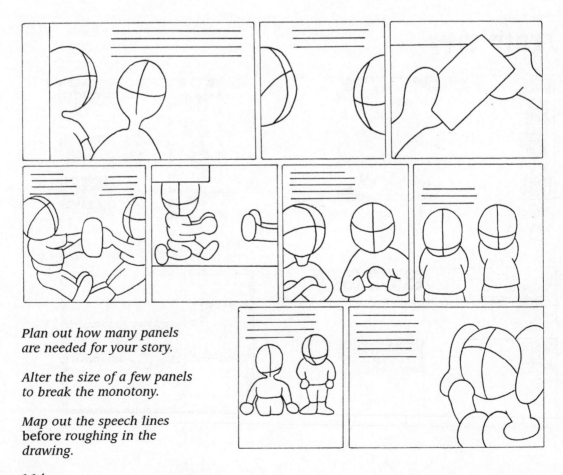

Plan out how many panels are needed for your story.

Alter the size of a few panels to break the monotony.

Map out the speech lines before roughing in the drawing.

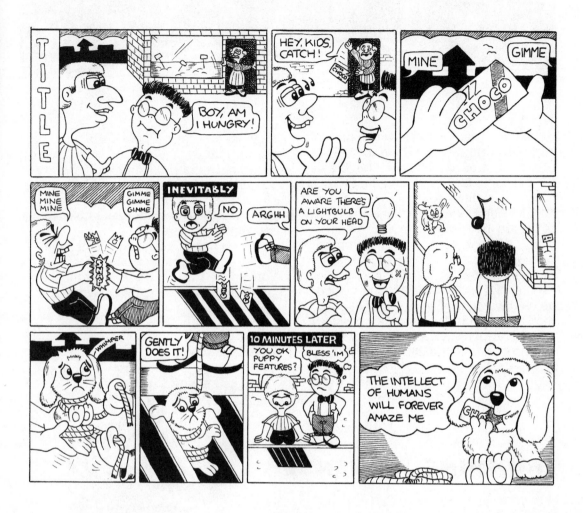

There is basically no difference between a comic strip and a comic book story except that the latter is a lot longer and normally fills up a whole page. Design, sketch and ink your comic page on to thin white card (A4 size) as you would a comic strip. Once completed, your work can be coloured using water paints or pencils. If you have a few quid spare then get your work colour-photocopied so that you can send your samples to more than one editor.

Visit your local library or bookshop to obtain a list of all comic book companies and select a few to view your work.

ANIMATION

EH WHAT'S UP TOM!

Does a place exist anywhere in the civilised world where animation really needs an introduction? Animation is all around us, in fact, everything that moves is said to be animated.

I love animation, it really is the cream of the artistic world! Almost everyone enjoys a *Tom and Jerry* or *Road Runner* cartoon but not a lot of people know how much intense work and skill go into the making of a cartoon. If you're not clued up on the technical side of animation then be prepared for a shock. A basic five-minute cartoon such as a *Bugs Bunny* short contains over 7,000 completely

separate drawings, all of which have been carefully drawn and painted before being filmed at 24 drawings (frames) for every second on screen. When these frames are played back at 24 frames per second (FPS), the illusion of movement is created and we have a cartoon.

If you are interested in becoming an animator, you would certainly benefit from some training. Try to enrol in a nightschool or college that caters for the budding animator.

RUNNING SEQUENCE

FRAMES CELS

STORYBOARD

KEYS

PENCIL TESTS

So How's It Done?

To get a clear and basic understanding of the fundamentals of animation, I'm going to take you step-by-step through the full process of creating a cartoon. Obviously, I'm not about to re-create *Aladdin* or *The Lion King*; our cartoon will simply involve a cartoon character looking from left to right in an office before picking up the phone and storming out. Not very impressive I know but I just want to give you some insight into the incredible amount of work and skill involved in animation.

1 STORYBOARDS

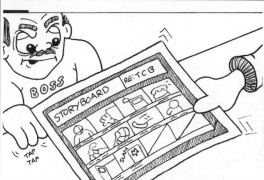

The storyboard is like a comic strip preview of what the cartoon is going to be about.

2 MODEL CARDS

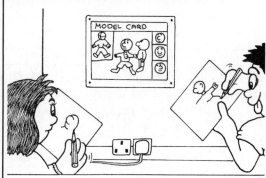

A model card shows the characters that will be in the cartoon describing their personalities and roles.

3 PENCIL TESTS

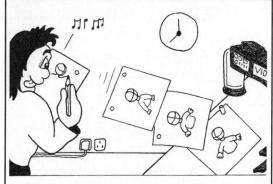

Rough animation tests need to be carried out to check that the movement is how the studio wants it.

4 CELS

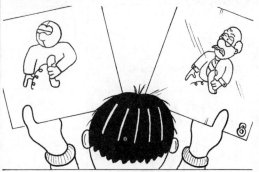

The pencilled frames can now be transferred to the cels and painted ready for filming.

Storyboards

To begin a project, the director has to intake as much information and ideas as possible to create a storyline so that it can be laid down in a comic strip form for everyone to see. A storyboard is the most efficient way in which the chief animator and director (me) can communicate to the assistant animators (you) exactly what I want to achieve without having to explain it repeatedly.

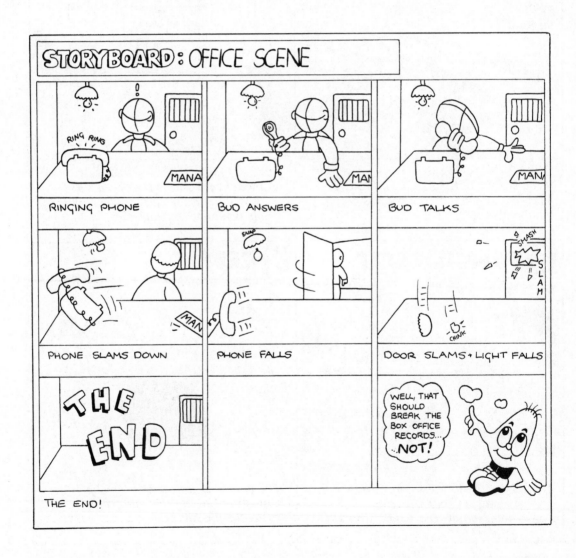

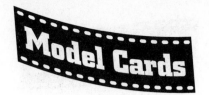

Model Cards

Once all of the animators are familiar with the storyboard, they then need to get to know the stars of the show. All of the animators need to know how to draw all of the characters in the same way so once the artist has created a character, he or she (I'm not sexist) will then draw it in various positions with lots of different expressions along with a detailed description of its personality and role in the cartoon.

Model Card: BUD — **Ref - 218**

FRONTAL

FRONT 3/4 RIGHT R. PROFILE

BODY FACE

SIDE BACK

NOTES CROSS

PEAR-SHAPED HEAD ORDINARY OFFICE SHOES SAD

EXTRAS WORRIED

HALF-MOON GLASSES STRIPE PATTERN TIE.

RING CRAFTY

Pencil Tests

This is the stage where the really hard work starts to take place. We want to check that our character will look left to right and pick up the phone correctly before the final drawings take place. The chief animator will draw up the key frames (in this case the keys are 1, 4, 7, 12 and 15) and from here, the assistant animator can link the key frames together with 'in betweens' to create a running sequence of frames to be used as a rough guide for the final drawings.

1	In between	In between	**4**
In between	In between	**7**	In between
In between	In between	In between	**12**
In between	In between	**15**	

Once all of the pencil test drawings are complete, they can then be filmed one at a time and played back at 24 FPS so the studio can check for any errors.

Backgrounds

Meanwhile in a spooky corner of the studio the layout artist will be hard at work creating the backgrounds. In our case, only the one background is needed (the office) which will show everything that will not be animated.

Sound Sheets

Amongst all of the confusion, a sound sheet should emerge from somewhere. The sound sheet informs everyone of what sound effects (and music) should appear between certain frames. Our animation has only a handful of sound effects such as a ringing phone and a slamming door.

Sound sheet / office scene														
S F/X	FRAME Nº													
	Ø	5	10	15	20	25	30	35	40	45	50	55	60	65
PHONE RING	▨		▨		▨									
PHONE SLAM									▨					
DOOR SLAM													▨	
BULB SMASH														▨

Cel Breaker

The next job for the studio is for the linesman to take the rough frames and trace over them so they will be left as a thin black outline. From here, these frames can be transferred on to sheets of celluloid (cels) either freehand or by a form of photo-transfer. Cels are simply thin, clear transparent sheets of plastic which can be laid over the backgrounds. Before cels were invented, the animators had to draw the entire background for every frame and that's exactly what the great Windsor M'cKay did for one of the first-ever cartoons *Gertie the Dinosaur* way back in 1926. (Phew!)

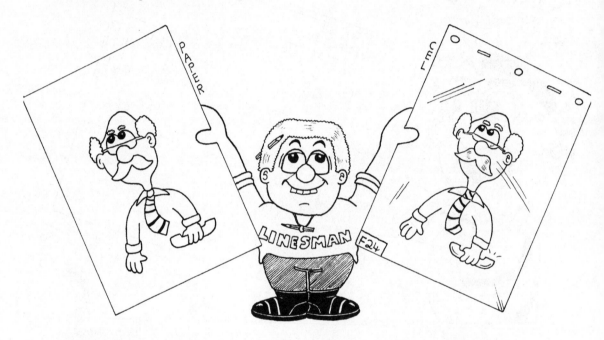

THE LIGHTBOX

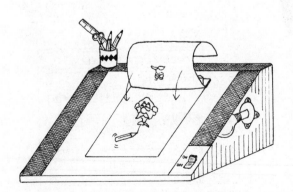

This ancient-looking piece of equipment is, as the name suggests, the lightbox. This contraption helps the animator to trace over the rough drawings with exact precision. The light bulb which is conveniently built in underneath gives the paper a transparent effect just like tracing paper!

nce all of the cels have been fully prepared, they can be taken to their final destination – the movie set. The cels can then be placed one at a time over the background and filmed at a speed of 24 to the second.

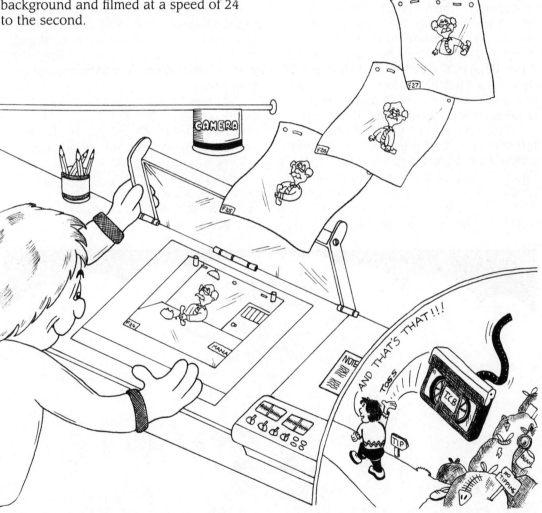

And that's how a cartoon is made – not exactly an overnight job! Now try to imagine repeating that process again, only this time using over 300 different backgrounds and about 60 characters, not forgetting sound effects and music, all lasting for around 90 minutes (almost 130,000 separate frames). Sounds pretty impossible but this is just what the Disney team does to provide us with excellent movies such as *The Lion King*, so the next time you see a cartoon – appreciate it!

IDEAS

When people view my work, I nearly always receive the same familiar response, 'Tel, where do you get your ideas from?'. The answer to this is . . . I don't know, I really don't. Ideas to me are like a gust of wind on a calm day – invisible, unforeseeable but then suddenly there, bang out of the blue! What triggers these unpredictable flashes of inspiration, not just in cartoonists but musicians, writers, performers and even the average Joe returning from an unsuccessful interview, is a total mystery. Most people, if they want a good idea, will take time out, sit back and think and will eventually produce some good results, but the best original ideas hit us unexpectedly, without warning, when we least expect it.

Always carry a notebook and pen wherever you go (this doesn't mean you have to glue them to the back of your best jeans but make sure they are always at hand). Sudden ideas travel up from the far depths of the subconscious mind and soon return there to be lost and forgotten so write them down before they entirely disappear.

All of us have a sense of humour (politicians excepted) and a sense is exactly what it is. We can sense whether something is funny or not and it's up to the cartoonist to bring his or her humorous ideas to paper; but always remember, what one person finds hilarious may well send the next to sleep with boredom.

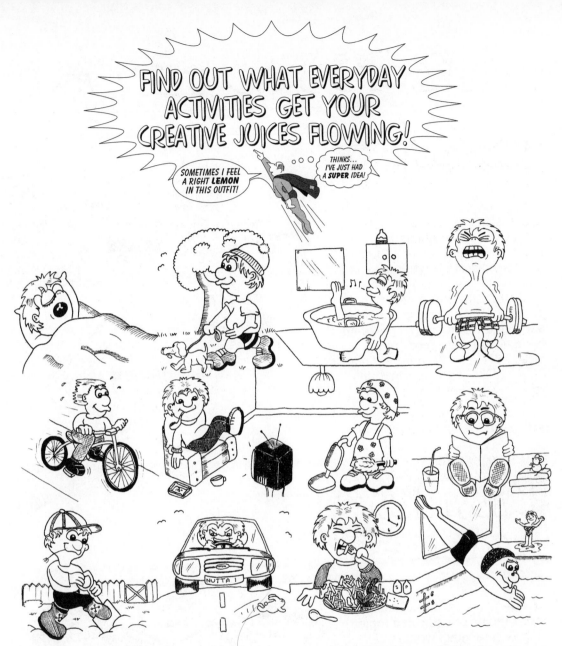

Creating gags can sometimes be very frustrating (nothing is more ugly than a blank piece of paper). There will be many a time when your mind decides to switch off (writer's block) and, no matter how hard you try, no ideas come to you. If you do get writer's block, don't spontaneously take to your immediate surroundings with a sledge-hammer. Instead, put the kettle on, sit back and relax (it's much cheaper).

Try to discover at which point of the day your creative juices are flowing most strongly! I can think up half a dozen great gags during the morning but come evening my mind goes blank and so my day is split: morning for ideas and evening for drawing them, and this arrangement works nicely. Find out what puts you in the right frame of mind for ideas. Could it be that just after a tasty meal, during a bath or after a brisk walk that your creativity peaks? Find out and use it to your advantage.

125

HINTS AND TIPS

Discipline

Discipline yourself to look and listen to everything that is going on around you at all times, mentally digest everything! Read lots and lots of humorous books, study the cartoons in newspapers and magazines because the more audio and visual information your brain takes in, the more funny ideas will occur. Even listening in on pointless gossip can broaden your creative horizons.

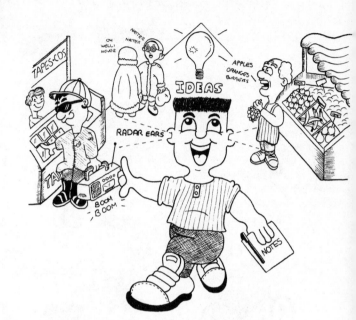

Know Your Audience

Most magazines usually have a theme or dedicated topic such as gardening, women of the nineties, cars, etc., and prefer to buy jokes relating to their particular subject matter, so if, for example, you're planning on sending some jokes to a car mag, then try to keep all the jokes car-related.

Causing Offence

Whatever the type of joke you think up, it will inevitably offend someone or other (people seem to take things so personally these days). Don't intentionally set out to offend unless you are sending to a magazine that prefers this type of black humour. Try to avoid sensitive subjects such as racism, homosexuality, death and the physically disadvantaged. Keep your jokes on a 'family' level.

And Finally

What did the big chimney say to the little . . .' Yeah, yeah, we've heard it before – yawn. Keep all of your ideas new, fresh and original. People don't want to hear jokes that they have heard before, there's no humour the second time around, it loses its punch, so just as a magician never repeats his tricks, a cartoonist should never repeat an old gag.

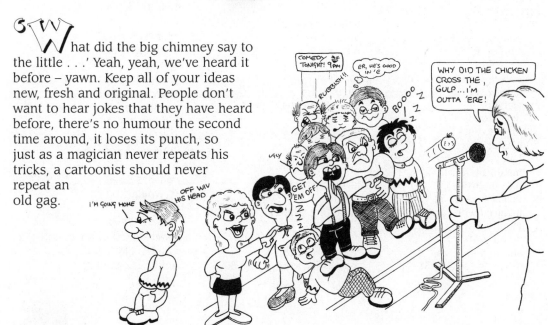